IMAGES
of America

THE SUNNYBROOK BALLROOM

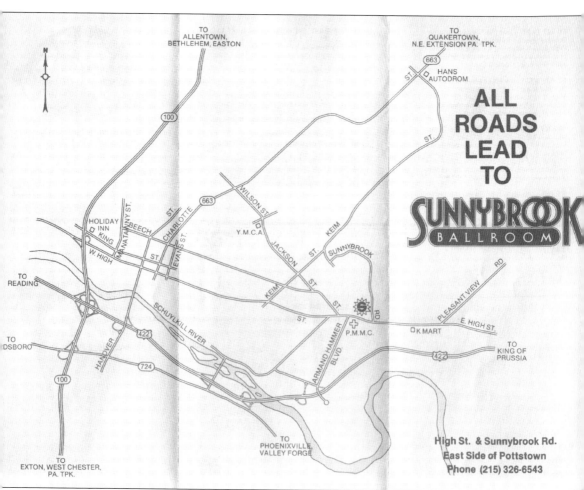

This brochure from the 1970s claims that "All Roads Lead to Sunnybrook Ballroom." Beforehand, at the height of the big band era, this was true. Traveling across the country, most of the major bands of the time would have made a one-night stop at the famous ballroom. It was one of the primary stops coming out of New York and Philadelphia as the bands began their tours.

On the cover: In 1926, the Sunnybrook swimming pool was opened with a big splash. Built by two brothers-in-law, Harry W. Buchert and Raymond C. Hartenstine Sr., the pool and picnic grove became a local landmark. Several years later, in 1931, the brothers-in-law partnership built a modern ballroom on the site near the pool. What was once rolling farmland on the outskirts of town was built into a thriving business. (Courtesy of the SunnyBrook Foundation archives.)

IMAGES
of America

THE SUNNYBROOK
BALLROOM

Thomas Sephakis

ARCADIA
PUBLISHING

Published by Arcadia Publishing
Charleston SC, Chicago IL, Portsmouth NH, San Francisco CA

Printed in the United States of America

Library of Congress Catalog Card Number: 2007921841

For all general information contact Arcadia Publishing at:
Telephone 843-853-2070
Fax 843-853-0044
E-mail sales@arcadiapublishing.com
For customer service and orders:
Toll-Free 1-888-313-2665

Visit us on the Internet at www.arcadiapublishing.com

To my loving wife, Nancy, and to my family.
Also, to those members of the SunnyBrook Foundation and the
Friends of Sunnybrook who have worked so hard to preserve the place
we simply call Sunnybrook for its memories and its future.

CONTENTS

ACKNOWLEDGMENTS

Since the SunnyBrook Foundation was founded in 2003, the group has managed to enhance its focus of "Saving Sunnybrook" and has rallied vast public support for its overwhelming endeavor. As the author of this book, and as the chairman of the SunnyBrook Foundation, I cannot thank our supporters enough for their efforts and their generosity. Without their help, this pictorial history of Sunnybrook would not have been possible.

I would like to thank the Lower Pottsgrove and Pottstown Historical Societies as well as the Montgomery County Historical Society for allowing me access to their archives to conduct research. I would also like to gratefully acknowledge the many people who donated a multitude of photographs for this work and to all those who provided the interesting stories and inspiring memories of Sunnybrook. I would like to especially thank the following people: Nancy Hartenstine, Amy Hartenstine Daniels, Dominic DeRenzo, George Batman, Norman Faut, Fred Hoffman, Walt Pickell, John Bakay, Bill Krause, Susan Scholl, Arlen Saylor, members of the SunnyBrook Foundation, and many others. Through their eyes and their words, one can truly understand and appreciate the history that Sunnybrook holds within it walls.

Over the years, Sunnybrook has come to mean a lot to this area, and I am thankful for everyone who was able to provide me better insight into its history. I would also like to thank the many organizations, bands, businesses, supporters, donors, family members, and volunteers for their efforts in helping us preserve this landmark ballroom.

I also wish to thank my editor and Arcadia Publishing for bringing this project to life. I appreciate your contributions and hard work. I would also like to thank you, the reader, for helping to keep the memory of Sunnybrook alive.

Finally, I wish to thank my wife, Nancy, and my three children—Tommy, Kara and JoAnna—for your love, support, and understanding in everything that I do. And lastly, to all the other people who have such dear recollections of Sunnybrook, here is to a bright future once again and to creating new memories.

INTRODUCTION

The Sunnybrook Ballroom is a vivid and well-known landmark of the big band era. Even today, its huge facade beckons to its memorable history. A local monument to the past, Sunnybrook sits in a small valley just outside of Pottstown, Pennsylvania.

Sunnybrook Ballroom is one of the few remaining dance halls of the pre–World War II era still in existence. The facility began as a swimming club in 1926 when the owners built an ultramodern pool and picnic pavilion. The circular pool was the heart of this posh and sometimes private club. Often only the "well-to-do" swam in the refreshing waters of Sunnybrook.

After the Depression, in 1931, the owners constructed a huge ballroom on the picnic grounds. The addition was opened on Memorial Day, less than 10 weeks after construction started. During the big band era of the 1930s and 1940s, the ballroom rose to prominence as one of the country's great dance floors. The imported hardwood dance floor was considered one of the finest in the nation and still is today. Sunnybrook Ballroom soon became a haven for the big bands. As they toured from coast to coast, these big bands would often schedule Sunnybrook as a stop on their way from New York across the country.

From 1931 to 1933, some of the early names who played at the ballroom included Kay Kyser, Isham Jones, Horace Heidt, Jan Garber, Wayne King, Guy Lombardo, Ozzie Nelson, and the "Prince of Heigh-de-ho" Cab Calloway. Later Count Basie, Louis Armstrong, Duke Ellington, and Lionel Hampton would be added to this list as more orchestras paid Sunnybrook a visit.

In 1934, Hal Kemp also made his debut at Sunnybrook. Years later he would be featured in a *Life* magazine article while he was on tour at Sunnybrook in 1937, bringing national attention to the ballroom. Within just a few short years of opening, Sunnybrook hosted a cavalcade of stars. And this was all before the so-called big band era. The following years brought even more big names to Sunnybrook. Within four years of opening, Sunnybrook was permanently added to the register of tour stops for all the major bands. In June 1935, Benny Goodman played the first of his 13 appearances at Sunnybrook. In fact it was at Sunnybrook that Goodman introduced his new vocalist Martha Tilton before she became a household name.

While the local house band, that of Leroy Wilson, continued to play the opening acts and shows in between, Sunnybrook thrived in the swing era. In 1935, before their classic falling out, the Dorsey Brothers Orchestra appeared twice. In the early 1940s, Tommy Dorsey introduced his new vocalist Frank Sinatra, who also appeared several times at the famed ballroom. Over the years, Tommy and Jimmy Dorsey would play at Sunnybrook more than 35 times combined.

Beginning in 1937, more big names soon appeared at Sunnybrook, playing to massive sold-out crowds—Sammy Kaye, Bob Crosby, Woody Herman, Artie Shaw, Larry Clinton, Harry James,

Charlie Barnet, Will Bradley, Gene Krupa, Glenn Miller, Charlie Spivak, Vaughn Monroe, Tony Pastor, and Claude Thornhill.

Over time, the owners built up a personal acquaintance and friendship with many of the bandleaders, who would tell their agents to include Sunnybrook on their itinerary. People from all over the Philadelphia area, and even parts of New Jersey and Delaware, would venture to Sunnybrook to see their favorite bands in person onstage.

The early 1940s were noteworthy years at Sunnybrook. The sheer size of the ballroom and its capacity helped Sunnybrook attract the best bands of the day. Tommy Dorsey often drew the best attendance, with standing-room-only crowds of more than 6,000 on several different occasions. However, the attendance record of over 7,300 people was set in February 1942 by Glenn Miller before disbanding his orchestra to go into the U.S. Army Air Force. Later, after Miller's death, the Glenn Miller Orchestra led by Tex Beneke played there 17 more times.

The list of bands that played at the ballroom read like a who's who of the big bands. Those famous names included Will Osborne, Will Bradley, Sonny Dunham, Harry James, Les Brown, Claude Thornhill, Eddy Duchin, Glenn Miller, Tommy Tucker, Louis Prima, Rudy Vallie, Tommy Reynolds, Bob Chester, Charlie Barnet, Alvino Rey, Tony Pastor, Casa Loma, Vaughn Monroe, Tommy and Jimmy Dorsey, Dick Rogers, Ray McKinley, Benny Goodman, Russ Morgan, Sauter and Finnegan, Bunny Berigan, the McGuire Sisters, and Frank Sinatra.

But the fanfare was short-lived as Sunnybrook closed in July 1942, for the duration of World War II. The ballroom was feeling the effects of gasoline rationing and the military draft, which hindered its business. Also, as the war effort grew, many of the bandleaders and their musicians were either in the service themselves or playing in USO shows entertaining troops around the world.

After the troops came home, Sunnybrook was in the full swing of things once again. The ballroom officially reopened on September 8, 1945, with Vaughn Monroe and his orchestra. Before the year was over a number of old favorites, including Benny Goodman, Woody Herman, Charlie Spivak, Charlie Barnet, and Tommy Dorsey, were back, along with newcomers such as Randy Brooks, Buddy Morrow, Stan Kenton, Bobby Sherwood, Ralph Flanagan, Ray Anthony, Les Elgart, Hal McIntyre, and Lawrence Welk.

Over the years, Sunnybrook also took part in radio broadcasts. Both before and after the war there were regular remote radio pickups from Sunnybrook over station WRCV in Philadelphia and also on nationwide broadcasts over the CBS or NBC networks. On several occasions, Sammy Kaye provided the show for these radio broadcasts at Sunnybrook.

As the 1950s changed the venue of musical performances, the big bands soon gave way to rock and rollers. Soon names such as Billy May, Ralph Marterie, Buddy Rich, Neal Hefti, Maynard Ferguson, Si Zentner, and local favorite Arlen Saylor gave way to performers such as Bill Haley and the Comets, Ozzie Nelson, Chubby Checker, and others such as Dick Clark, who helped usher in a new generation.

The bands had changed and so did Sunnybrook. To help support its business, in the summer of 1963, a restaurant and bar were constructed next to the ballroom. In time, the big bands had come and gone, but the memories for all who enjoyed them lingered.

Recently the ballroom was used primarily for various functions: high school proms, wedding receptions, charity balls, community banquets, political rallies and dinners, trade shows, dance shows, and polka festivals. On occasion, the big bands would also make an appearance "for old time's sake."

Today the ballroom is a grandiose reminder of Sunnybrook's day as "the home of the big bands" when virtually all the top names appeared there to perform. From coast to coast, people recall the name of Sunnybrook and share the memories. Everyone from the local area has a story to share about his or her days sitting beside the pool or dancing the nights away in the ballroom.

Sunnybrook is a vital piece of Americana that remains to be reawakened for a new generation to enjoy and to create new and lasting memories for years to come.

One

SUNNYBROOK IN
THE BEGINNING

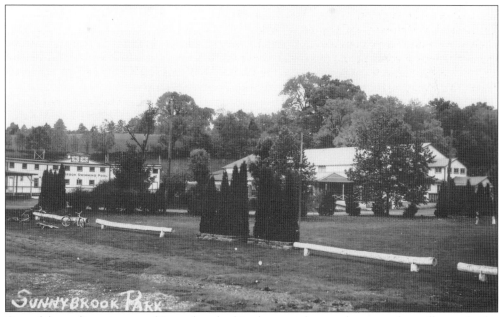

One of the earliest pictures of Sunnybrook, this photograph was taken near the trolley car bridge at the eastern end of the property. Through a small rise of pine trees, the swimming pool is visible on the left. To the right of the swimming pool is the newly constructed grand ballroom. Visible just in front of the ballroom is a portion of the original covered pavilion beside the pool.

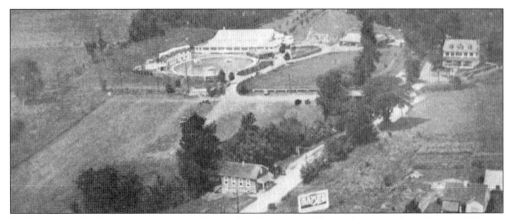

Built on nearly 17 acres of property, Sunnybrook was visible at the time from Route 422 and High Street. This picture is one of the first taken of the new ballroom. Taken from a biplane flying over Route 422, this shot gives a good idea of the size of the buildings. At the upper right of the photograph is the family's original farmhouse dating from the late 1700s.

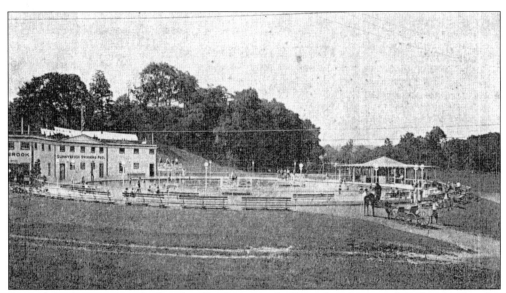

One of the first stops on the local trolley line was the Sunnybrook swim club. For the first few years, the family operated it as a private pool, but they later opened it to the public. Here a horse-drawn carriage makes its stop, perhaps to drop the children off for a day at the pool. In the foreground are the tracks and overhead the electrical lines for the trolley cars.

In 1732, the Bickel family was granted more than 22,000 acres of land outside Greater Philadelphia. This precious farmland was eventually subdivided into various plots and included land in what is today Pottstown, Sanatoga, and Pottsgrove Townships. Here is a later drawing of the family descendant Lewis Bickel who inherited the farmland from his ancestors and began to sell off property to other farmers.

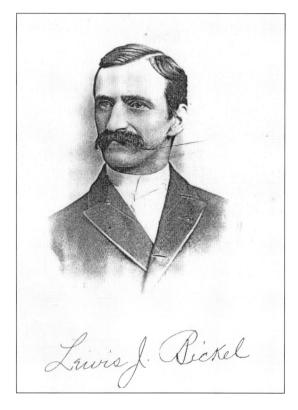

Lewis J. Bickel

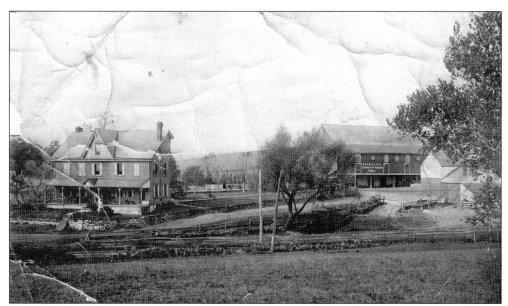

Standing across Sprogel's Run Creek is the original farmhouse and barn. The farmhouse itself dates back to the mid-1700s and was remodeled and added to over the years. This image was taken in the early 1900s and shows the I. A. Kepler Farm, as it was known at the time. The farm was a working facility from 1732 until 2001, when the property was sold off for further development.

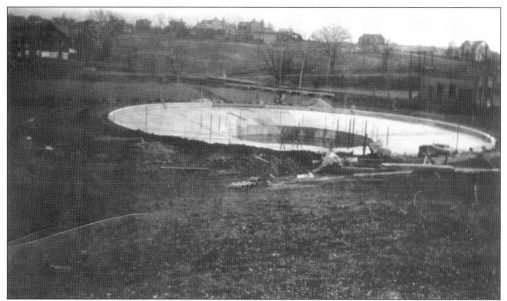

It was 1926 when the Sunnybrook swimming pool began construction and opened a few months later. This is one of the first images of the pool itself as it was being built. The large circular concrete basin had just been poured. To the back right of the photograph the newly built trolley station is also visible. Many people thought it crazy to build a pool in the middle of farmland.

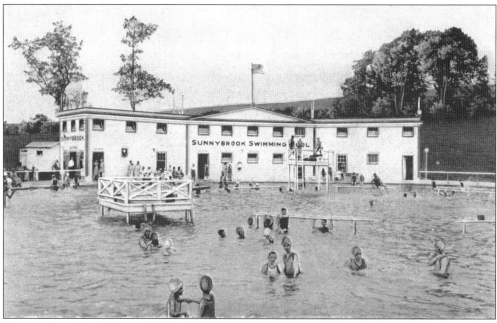

This early postcard shows swimmers at the private swim club. The huge round pool was approximately 15 feet deep in the center. It sloped gently inward to the center. Here bathing beauties from the late 1920s are shown in the foreground with their swimming caps. The barriers in the center mark the deep end, and at the far end of the pool is the diving platform.

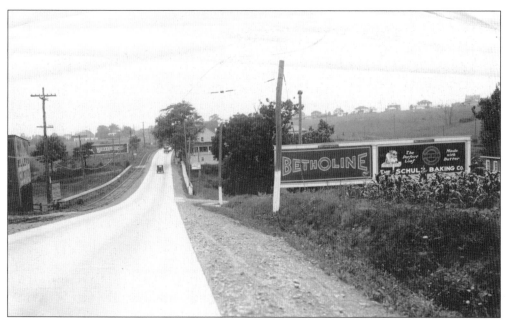

Taken in late 1929, this view looks west along High Street over the stone bridge and toward Pottstown. At the time, the bridge provided passage for vehicles, carriages, and also a trolley whose tracks are visible to the left of the picture. The dirt roadway just behind the two billboards to the right was the entrance road to the Sunnybrook swimming pool. This road was later renamed Sunnybrook Road.

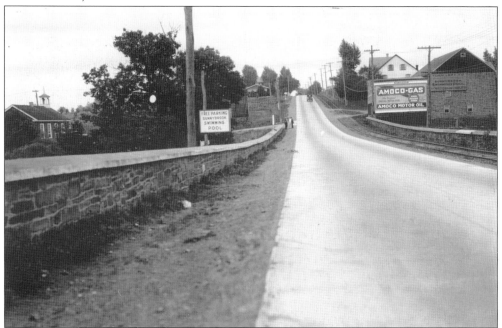

Looking east on the bridge at High Street, this picture was taken in 1929. On the right side of the bridge, the trolley tracks can be seen clearly. On the left of the bridge is a small sign for free parking, as well as a glimpse of the old schoolhouse. Across the bridge, mounted on the barn, is another sign that tells drivers to turn left to enter the pool.

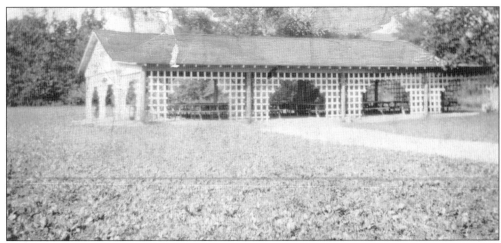

This is a 1929 image of the second, larger picnic pavilion at the Sunnybrook pool. About 50 yards from the original pavilion, which was at the poolside, this second pavilion was built to house larger gatherings for the Sunnybrook patrons. Over the years, this building housed reunions, company picnics, and social gatherings and the like. In 1999, a new modern pavilion took the original's place on the property.

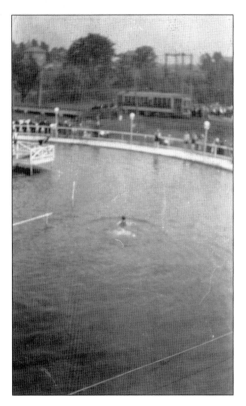

This late-1920s photograph was taken from atop the pool house and facing south. This very rare image shows the local trolley in the background. For years, Sunnybrook was a stop along the trolley line that ran from Pottstown to neighboring Sanatoga Park just a few miles down the road. Here a crowd of people is disembarking from the trolley for a day at Sunnybrook.

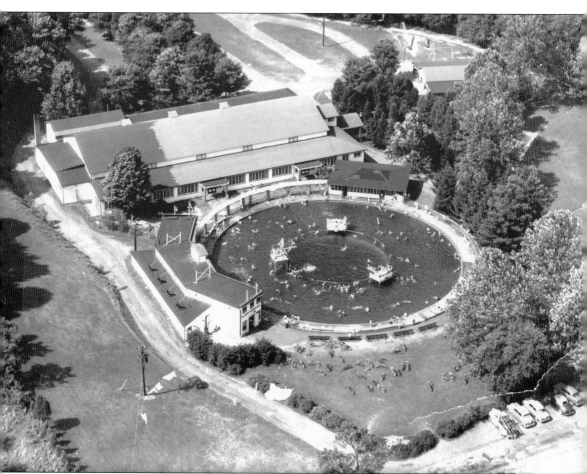

This is an aerial view of Sunnybrook taken in the early 1940s. A clear summer's day shows the multitude of swimmers enjoying the pool. In the early 1930s, after the ballroom was built, the pool itself was opened to the general public. The trolley tracks have now vanished, replaced by dirt roadways for the cars and buses that now brought people to the famous pool. At the top right of the picture, hidden in the trees, is the picnic pavilion. At the right end of the ballroom, next to the pool itself is the first pavilion for the swimming area. Between the pool house and the swimmers' pavilion was a canopy of wooden trellises that surrounded the pool to the north end. Before a new concession stand was added, the pavilion served as the first concession area. When that smaller pavilion was removed, a storage room and new concession stand were built into the side of the ballroom itself.

Behind the second picnic pavilion at Sunnybrook was a small parklike setting complete with additional swings, sliding boards, horseshoe pits, and more. In this image, one also gets a glimpse of the fire pit that was built near the creek bed. Besides the swings, slides, and teeter-totters near the pool, this pavilion was built to accommodate private functions and gatherings.

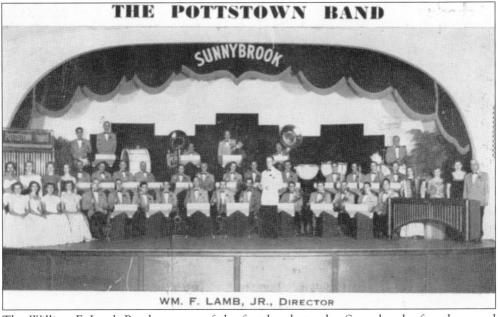

The William F. Lamb Band was one of the first bands to play Sunnybrook after the grand ballroom was opened in 1931. The ballroom was constructed between April and May and was formally opened on Memorial Day of May 1931. The large stage was able to easily accommodate the big bands and orchestras of the era. This image was taken before what is now called the big band era.

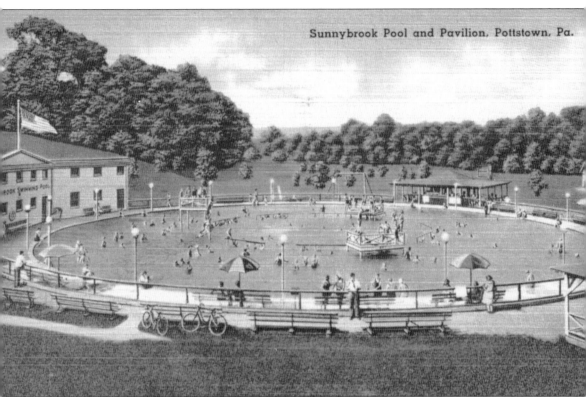
Sunnybrook Pool and Pavilion, Pottstown, Pa.

A beautifully hand-drawn postcard from the late 1920s shows the Sunnybrook pool looking north. This postcard was originally done in vivid colors and sold at the pool for general postal use. The large wooden bathhouse to the left housed the changing rooms and in later years the ticket office. This building would have been painted in white and green. To the right, near the covered picnic pavilion were a few park items, such as swings and sliding boards for the children to enjoy after their cooling swim. Just behind this pavilion, the ballroom foundation would have been laid several years later. This postcard, without the ballroom, is dated from 1927 or 1928. Over the years, the owners actually printed several different postcards, including later ones with photographs. However, the older painted cards were the favorite of collectors in and around the region.

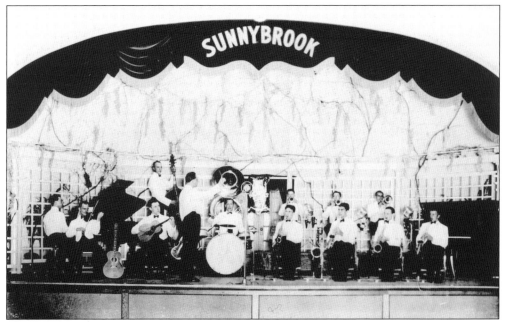

With the dawning of the big band era, the Sunnybrook owners began to book more of the orchestras to come and play at their new ballroom. With the opening of the new ballroom, the owners thought it wise to begin bringing more music to the region. Within just a couple years, Sunnybrook would be a haven for the big orchestras.

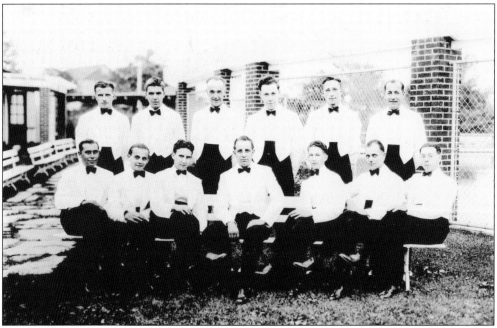

A close-up picture of the same band was taken earlier outside the ballroom on the day of its performance. The band is seated at the gates near the swimming pool. This location is near the backstage entrance of the building. Many performers did afternoon and evening shows on Saturdays and Sundays to a full house.

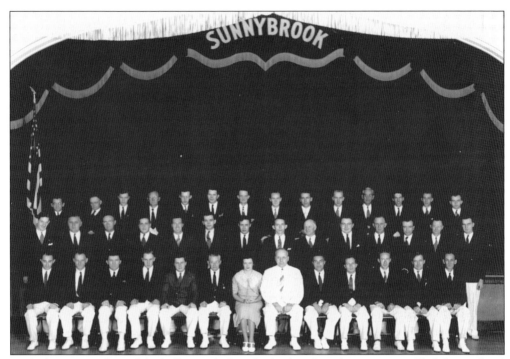

In the beginning days of the ballroom, before the big bands and swing music filled the air, local organizations and clubs used the facility for their gatherings. A host of organizations filled the ballroom for reunions, meetings, anniversaries, and other events. This picture is of a local group of men gathered for what is believed to be an organizational picture in the ballroom.

After building the ballroom, which was opened on Memorial Day 1931, Sunnybrook became one of the first major ballrooms to welcome in the big band era. By 1932, Sunnybrook was also hosting nationwide radio shows from its famous stage. This particular ticket from January 1932 mentions Don Bigelow who will be performing and broadcasting for the Columbia Broadcasting Company. Back then, admission was only 75¢.

Sunnybrook Ball Room

SATURDAY EVE. JANUARY 23, 1932
A REAL TREAT TO THE MUSIC LOVER

T A L H E N R Y
THE PERSOSALITY PRINCE AND HIS

NORTH CAROLINIANS
FAVORITE OVER W. J. Z. FROM THE HOTEL NEW YORKER FOR THE PAST 12 MONTHS.

They are renowned the country over for their N. B. C. Broadcasts, having enterized the most popular tunes from the Hotel New Yorker, and for their best selling Victor Records.

ADMISSION ONLY - - 75c

SATURDAY EVE. JANUARY 30, 1932
COLUMBIA BROADCASTING CO.
PRESENTS

D O N B I G E L O W
AND HIS

Columbia Broadcasting Orchestra
TO APPEAR AT SUNNY BROOK BALL ROOM
Coming direct from Young's Chinese American Restaurant N. Y. for his first appearance in a public ball room for nine months, who has broadcasted daily over stations W. I. P. — W. F. A. N. W. P. G. — W. A. B. C. and became quite a favorite to all music lovers.

ADMISSION ONLY - - 75c

This "coming attractions" ticket is from 1932. A year later, the ticket prices had jumped by 25¢, and most shows were $1. Luckily the price remained fixed for Kay Kyser and his band Southern. Performing on what was dubbed Decoration Day, Kyser was returning to Sunnybrook once more. However, one might notice the misprint on the ticket itself. Kyser was actually scheduled on May 30.

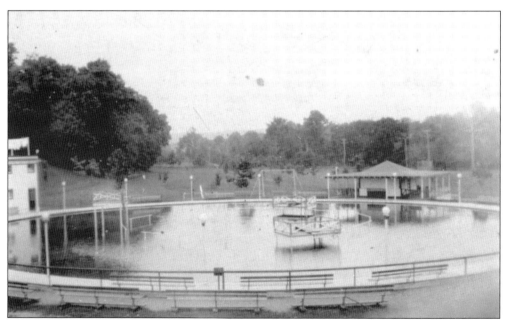

This is one of the earliest photographs of the Sunnybrook pool. At the time of this picture the pool was still a private swim club serving the greater Pottstown region. The original pavilion and concession stand are visible on the right side. To the left, towels can be seen hanging atop the pool house. For many years, the management rented not only towels but swimsuits as well.

Two

THE SUNNYBROOK
POOL AND PAVILION

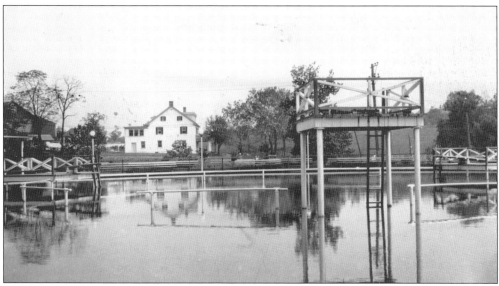

For many years, the original farmhouse and barn were visible across the roadway from Sunnybrook. This was the very same home where the original founders of Sunnybrook, Harry W. Buchert and Raymond C. Hartenstine Sr., lived with their spouses. Several generations of the family were raised in this home that stands today. Hartenstine passed away in this very home, just a short distance from his famous ballroom and swimming pool.

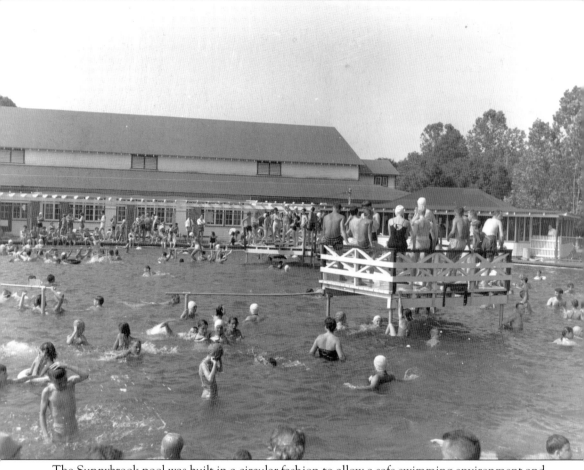

The Sunnybrook pool was built in a circular fashion to allow a safe swimming environment and high visibility for the lifeguards. The pool itself had three diving stations, two low-level dives and one high dive. The high dive was eventually removed for safety reasons. The pool itself was constantly filtered and used water from two artesian wells on the property. In the beginning, to promote sanitary conditions, the massive pool was drained every day and refilled with fresh water the next morning. Besides the swimming pool, Sunnybrook offered picnic groves, a refreshment stand, several sports fields, and another large pavilion for guests to use. Of course, the main attraction was the ballroom that held weekly events. Across from the pool, in the 1950s, the owners even installed a children's railroad, where the kids and their parents could take a ride on a scaled replica train around the park areas.

Built in 1926, the Sunnybrook pool began its life as a private swim club for locals in the Pottstown area. When the famous grand ballroom was also added to the grounds, the pool opened to the general public. The 1940 advertisement shows a few different shots of the famous circular pool that was hailed as one of the best in the state.

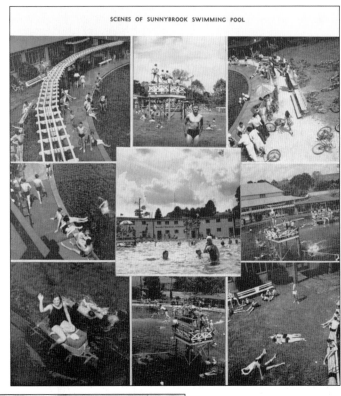

SCENES OF SUNNYBROOK SWIMMING POOL

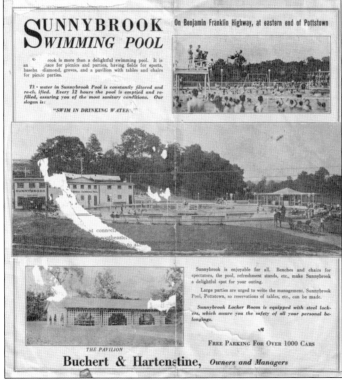

SUNNYBROOK SWIMMING POOL On Benjamin Franklin Highway, at eastern end of Pottstown

Sunnybrook is more than a delightful swimming pool. It is an ideal place for picnics and parties, having fields for sports, baseball diamond, groves, and a pavilion with tables and chairs for picnic parties.

The water in Sunnybrook Pool is constantly filtered and re-clarified. Every 12 hours the pool is emptied and re-filled, assuring you of the most sanitary conditions. Our slogan is:

"SWIM IN DRINKING WATER."

Sunnybrook is enjoyable for all. Benches and chairs for spectators, the pool, refreshment stands, etc., make Sunnybrook a delightful spot for your outing.

Large parties are urged to write the management. Sunnybrook Pool, Pottstown, so reservations of tables, etc., can be made.

Sunnybrook Locker Room is equipped with steel lockers, which assure you the safety of all your personal belongings.

FREE PARKING FOR OVER 1000 CARS

THE PAVILION

Buchert & Hartenstine, *Owners and Managers*

At the time this advertisement was printed, dated 1930, Harry W. Buchert and Raymond C. Hartenstine Sr. were still business partners and running the facility. Years later in the 1950s, Buchert retired and sold the remainder of his business to Hartenstine, who would eventually transfer it to his children. This foldout advertisement promoted the pool and picnic areas after they had become open to the general public.

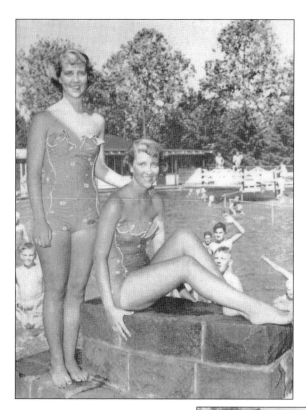

These bathing beauties were photographed in the early 1940s as the popularity of the Sunnybrook pool was on the rise. Often local newspapers and magazines would do fashion shoots at the poolside. Throughout the years, the newest fashions would be seen around the swimming pool at Sunnybrook. Many a young couple met at the pool and passed the warm summers in stride. Sunnybrook was now growing as a destination.

Another fashion spread for swimsuits from a later date is shown here. Taken by John P. Jones, this advertisement shows the new line of bathing suits as well as some interesting points around the Sunnybrook pool. The circular pool provided great vantage points from all areas and was a great pool for diving. Posing at the poolside became a fashionable pastime.

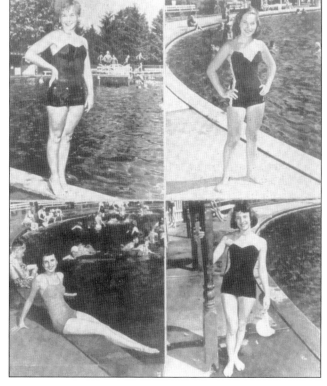

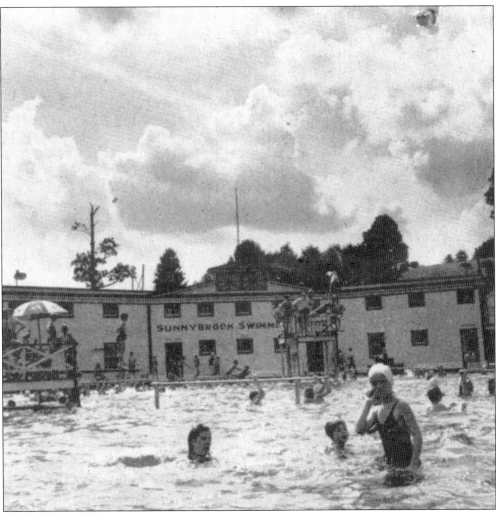

This shot was taken in 1940. Over the years, the Sunnybrook pool had become a local hangout. Here a bevy of happy swimmers delights in the pool. In the center of the picture is the diving platform, where one young man is trying to impress the girls as he takes the plunge. In the foreground, several young ladies frolic around with their bathing caps held tight. Ranked as one of the finest public pools in the state, the Sunnybrook pool became a model for pools in general. It was built in a circular shape for safety reasons. Lifeguards were posted on all sides, with two raised stations located in the pool itself.

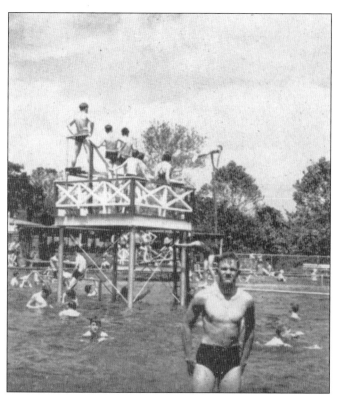

A lineup of young stars waits to take the dive into the pool as a crowd of onlookers watches. Using natural artesian water for its source, the Sunnybrook pool was one of the cleanest and freshest around. Just beyond the diving platform, one can see the pool pavilion and the corner of the ballroom. In the foreground, a young gentleman strikes a pose and flexes his muscles for the camera.

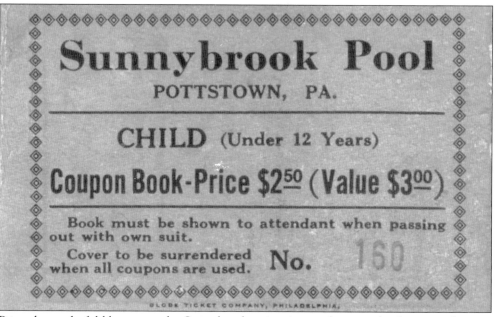

Sunnybrook Pool

POTTSTOWN, PA.

CHILD (Under 12 Years)

Coupon Book-Price $2⁵⁰ (Value $3⁰⁰)

Book must be shown to attendant when passing out with own suit.

Cover to be surrendered when all coupons are used. **No.** 160

Printed on colorful blue paper, the Sunnybrook swimming pool coupon books were a bargain at $2.50. This particular book from the 1950s was for children under 12 years. Along with the coupons and admission, swimmers could also rent a towel and even a bathing suit from the swimming pool management. Coupon books and individual coupons were started after the pool changed from being a private swim club.

It was the summer of 1947 when a photograph of Fern Drumheller was snapped at the Sunnybrook pool. In her new one-piece swimsuit, she is modeling the latest fashion of the day. She and other young beauties posed at the poolside, attracting the attention of the young men sitting atop the lifeguard platform just behind her and to the right.

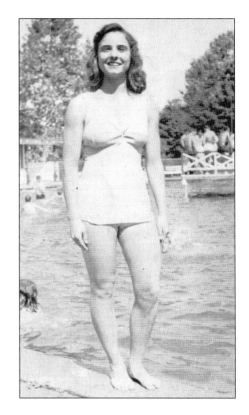

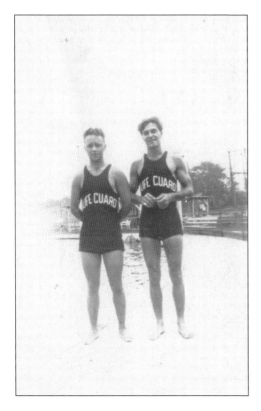

This late-1920s photograph shows two of the lifeguards on duty at the Sunnybrook swimming pool. Throughout the season, the pool would employ about a dozen different lifeguards. At any given time, there were six to eight on duty to watch the hundreds of swimmers in the massive pool. The pool itself was advertised to have a capacity of over 800 people.

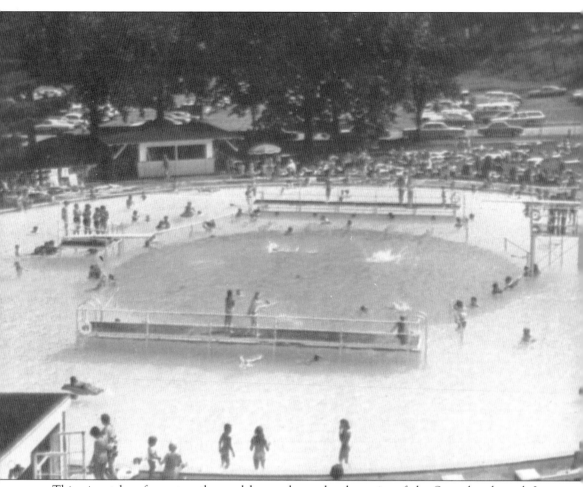

This view taken from atop the pool house shows the sheer size of the Sunnybrook pool. In comparison to older photographs, the huge diving platform has been removed and replaced by a metal walkway on both sides of the pool. At the right remains one of the earlier lifeguard stations. To the left, a new, low-level diving board was added to replace the monstrous platform of the earlier years. Where the swim pavilion had once stood was now empty space, and a new smaller pavilion was built for concessions. The small pavilion is at the top left of the picture near the poolside. At the top of the photograph a lot full of cars now occupies the location where the children's train had made its home for several years. Prior to the lower gardens being landscaped, this area was used for more parking.

Taken from the stone bridge on High Street that was built in 1910, this image looks northwest toward the swimming pool and ballroom. From the early 1940s, it shows the massive billboard that advertised Sunnybrook and special upcoming events. Here a Saturday night show on May 16 is promoted featuring Ray McKinley and his orchestra. At the time, this was one of the largest billboard signs along this roadway. The Sunnybrook swim club was an exclusive facility throughout its opening years and until the 1940s.

In the 1950s, a catwalk bridge was erected over the entry road to Sunnybrook's ballroom. The walkway was for swimmers who would venture out of the pool, across the bridge, and into what was known as the lower gardens. The lower gardens were originally a grassy picnic area. Later volleyball courts and even a basketball court were added to the lower gardens for the people to enjoy.

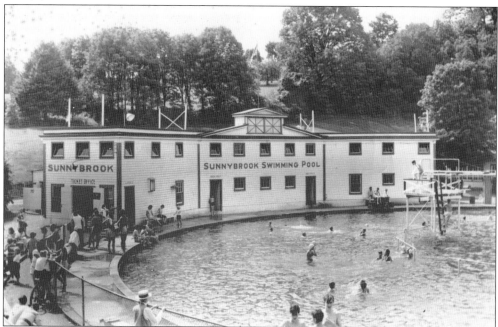

This image from the late 1960s shows a typical busy day at Sunnybrook swimming pool. A line of guests waits to the left as they are purchasing tickets for the day at the ticket office. Guests could pay for their admission tickets and also rent a towel and bathing suit. Eventually the bathing suit service ended after the swim club was opened to the general public.

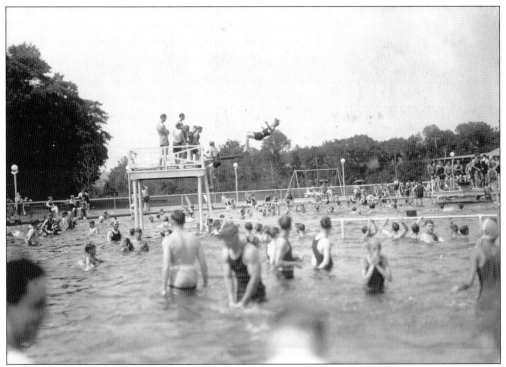

The high dive at the west end of the Sunnybrook pool was about eight feet above the waterline. Plunging into the center, the depth of the pool was another 15 feet. In a photograph taken from the 1920s, a brave young man does a backflip. At the time of this picture, the ballroom had yet to be built.

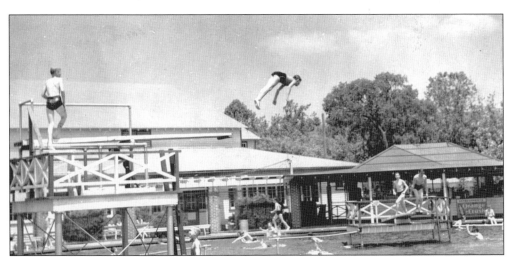

Sunnybrook swimming pool had one of the deepest water basins in the area and one of the highest diving platforms as well. Swim teams used the pool for practice, and divers often demonstrated routines. Although Sunnybrook did not have its own swim team, many local schools used it as a practice facility. Here a young diver demonstrates his skills.

This very early photograph from 1928 was taken during the morning at the Sunnybrook swim club, as it was known at the time. During the first few years, people had to be members of the pool. After the ballroom was built in 1931, the pool became open to the public for a price. Beyond the pool, where the small park is located, would become the eventual site of the ballroom.

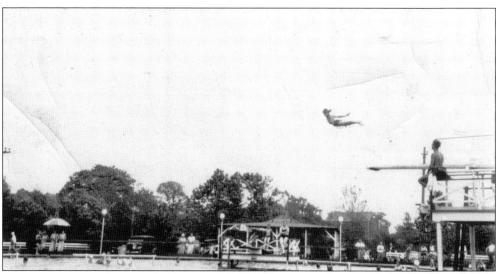

Divers from various teams would often demonstrate their skills to the crowds at the Sunnybrook pool. Various dives, such as a swan dive or a jackknife, could easily be accommodated because of the pool's deep bottom. This made it ideal for practice events. This photograph from the early 1930s shows the small covered pavilion at the south end just beyond the low-dive platform.

Three

THE BIG BAND ERA

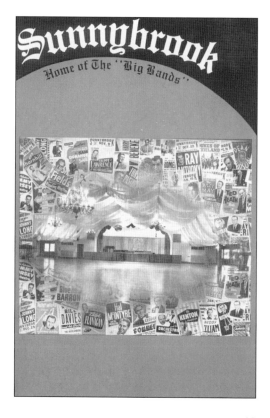

With a border of famous big band posters, the image of the massive Sunnybrook Ballroom is centered on this vintage menu cover. Some of the familiar names on the posters are a simple list of various bands that played there over the years. In the heyday of big bands, Sunnybrook was the largest ballroom east of Chicago. Even today, it is one of the largest remaining ballrooms in the nation.

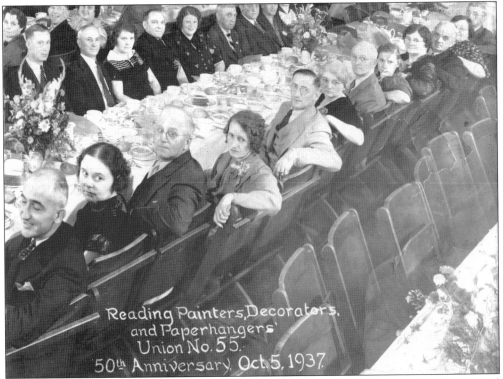

In 1937, the Reading Painters, Decorators, and Paperhangers Union No. 55 held its annual dinner at the famed Sunnybrook Ballroom. This particular event also happened to be the 50th anniversary celebration for the union. Traveling from the Reading area, about 30 miles north, the guests attended the dinner and dance festivity at the ballroom.

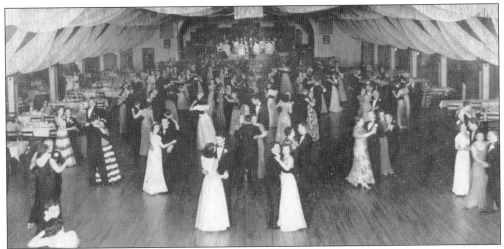

On April 26, 1941, the Pottstown Society held its annual charity ball at the Sunnybrook Ballroom. A host of local townspeople attended the fantastic event. Women in evening gowns were escorted by gentlemen in tuxedos as they danced to the big band sounds. It was said that the event lasted until the early morning hours.

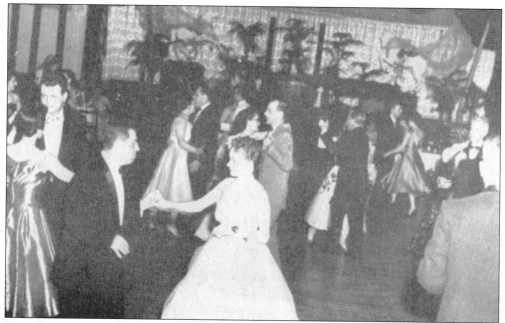

Over the years, many local events were held at Sunnybrook, where people could dance all night long. This evening the band was set up just offstage so that a local charity could display its carousel horses onstage. Note the two horses in the background. Over the years, those who came to swim at the famous pool soon asked for a dance hall; Raymond C. Hartenstine Sr. was happy to oblige.

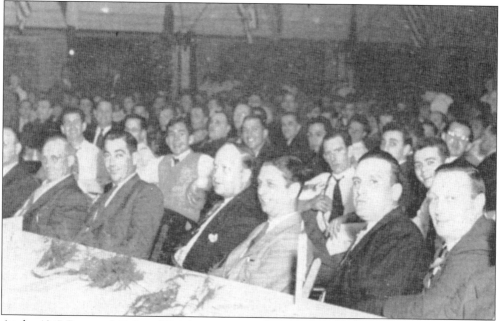

At the 1947 Fraternal Order of Orioles event, ex-servicemen were honored by borough officials, politicians, and club officers. The year 1947 marked the 23-year anniversary of the social club. Formed in 1924 with only 68 members, it grew to well over 2,200 members. This evening more than 2,000 of those members attended the event at Sunnybrook.

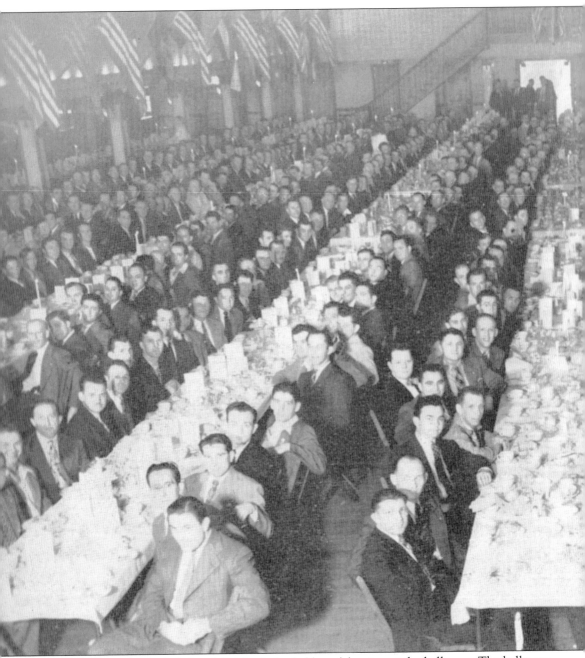

In 1947, the Fraternal Order of Orioles lodge held a celebration at the ballroom. The ballroom itself could hold several thousand people for specific events. Often for the social clubs of the era, Sunnybrook became a popular facility to host these types of events. The Fraternal Order of Orioles lodge was an organization that was focused on community service and progresses

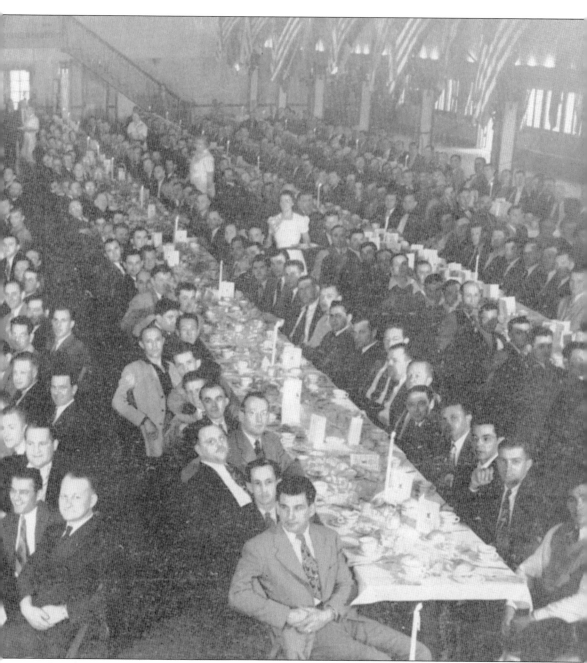

after the war era. This particular occasion was to honor the local servicemen of the area who had returned home after World War II. This event at Sunnybrook was a welcome home party for the war veterans who were given full honors at this celebration dedicated to their service and sacrifice.

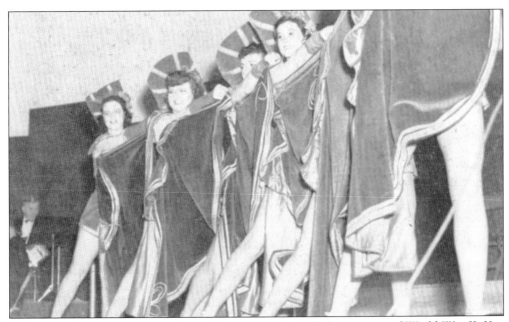

Dancers perform onstage at a welcome home event in 1947 for veterans of World War II. Yes, the stage was large enough to accommodate such shows. Years earlier, the massive ballroom also played host to a small circus. At the time, it was said that rubber mats were placed over the imported hardwood floor to protect it from the animals. Never again did Sunnybrook host a circus event.

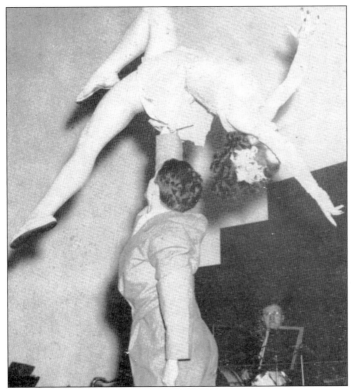

Again special performers do stunts onstage for a host of guests. The dance show lasted into the evening as a whole cavalcade of performers paid tribute to veterans of the war. Built after the Great Depression and surviving through the world war, Sunnybrook was again a stop for many of the day's performing acts.

This is a vintage poster of Woody Herman that once adorned the box office at Sunnybrook and hung in the office. In the upper corner of the poster, Herman signed a brief message to Raymond C. Hartenstine Sr. Over the years, the owners had become well known by the big-name performers and even called many of them friends.

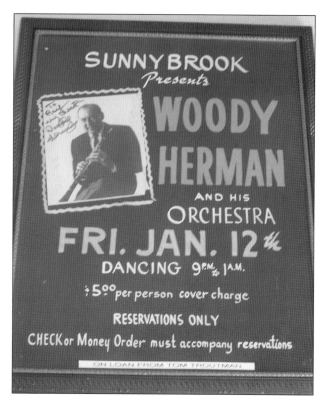

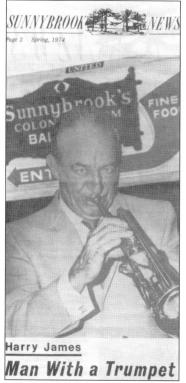

This photograph of the famous Harry James was taken at Sunnybrook during one of his many performances. Over the years, James returned to Sunnybrook numerous times as it was always a favorite venue for him and his band. Behind James, a sign for the Colonial Room restaurant hangs outside the ballroom.

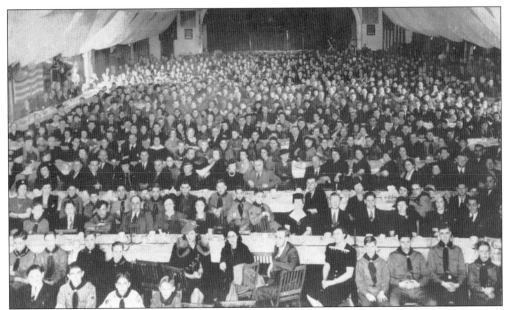

In 1941, over 1,100 Boy Scouts and their families filled the Sunnybrook Ballroom for a mother and father dinner. This was the 31st birthday celebration for the Boys Scouts of America. Local Pottstown Troop 1 was one of the first hundred troops originally formed. After a day of swimming, the festivities flowed into the ballroom for the evening. Imagine these children all in the pool earlier in the day.

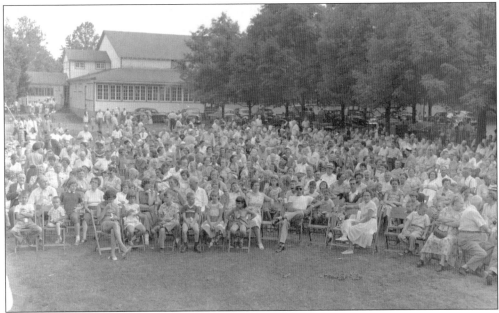

At the north end of the property, a huge gathering of people sits around on the lawn near the large pavilion awaiting a small outdoor performance of some guest musicians. This image was taken a few years after the end of World War II. Besides reopening the ballroom after the war, the owners also managed to utilize much of the remaining property for other functions such as this one.

This is a candid photograph backstage at Sunnybrook of Tommy Dorsey before one of his shows. Over the years, Dorsey played Sunnybrook numerous times and always had the biggest draws of people. During three separate events, Dorsey and his orchestra drew more than 6,000 people to the ballroom. As a matter of fact, Frank Sinatra also sang at Sunnybrook, as he was a new vocalist at the time with Dorsey's band.

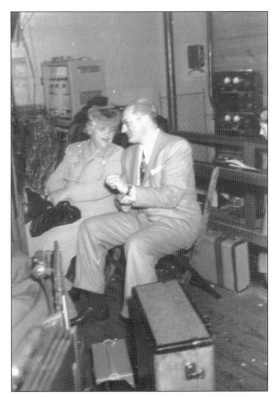

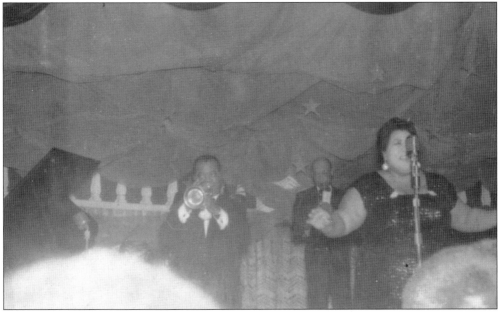

A rare performance from Louis Armstrong and his All-Stars is captured in this 1940s photograph taken at the Sunnybrook Ballroom. Over the years, Armstrong appeared at Sunnybrook over a dozen times with various guest vocalists. Satchmo was a local favorite and was also a friend of the owners and their family. This early photograph shows Armstrong entertaining the crowd and playing backup to his vocalist, Velma Middleton.

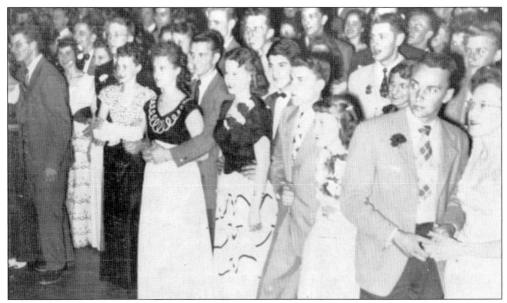

Taken from the side of the stage, this photograph is of the 1947 Pottstown High School Prom event. As with many of the events, the big band sounds helped to charm the young teenagers. Throughout the years, Sunnybrook has hosted hundreds of prom events just like this one. Men and women of all ages have joyful memories from their school events. Children from the area grew up at Sunnybrook.

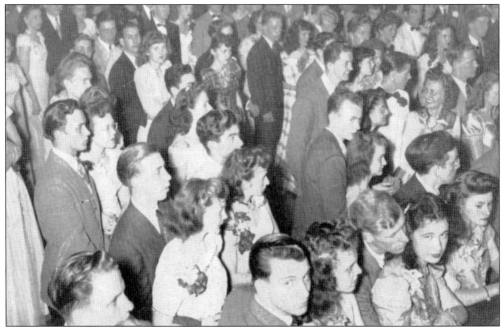

Pottstown High School students are enjoying music at the junior dance. Reopening its doors, one of the first events held at Sunnybrook was the Pottstown High School Prom. On D-day, June 6, 1944, the crowd of young students was informed that the Allied invasion had begun in Normandy. Emotions ran high for some, especially those young men who had enlisted, as the war might soon be coming to an end.

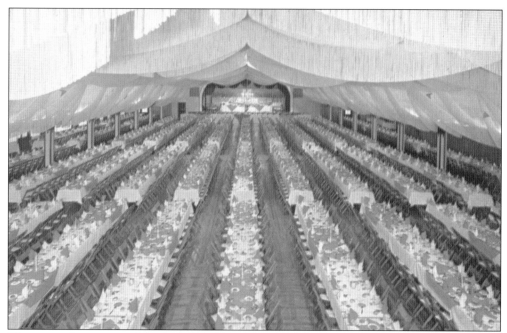

This magnificent view of the ballroom was taken from atop the stairs at the back of the room, above the entrance. Over the years, Sunnybrook has hosted many events with thousands of people in attendance. The draperies are hung high above the dance floor, and the tables have been set for the night's event.

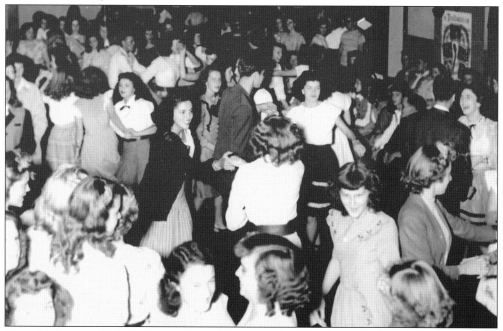

Cheerful dancers fill the ballroom floor of Sunnybrook as they listen to their favorite performers onstage. Near the back of the ballroom, a group of teenagers and some adults have gathered to display their dance moves and the latest steps. For the price of admission, one could dance all night long while hot dogs and soft drinks were sold at the refreshment stand.

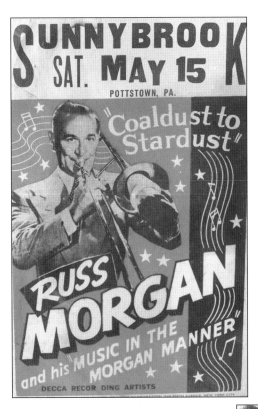

A poster hanging at the entrance of the ballroom displayed Russ Morgan at the Sunnybrook ticket office. Famous for his "Coaldust to Stardust," Morgan drew a huge crowd that evening of May 15, 1954. With the sounds of his trombone, Morgan pleased the local crowd as they danced well into the evening.

A collage of the big band leaders from Sunnybrook gives tribute to some of those famous names that performed there. This poster shows Tommy Dorsey, Jimmy Dorsey, Guy Lombardo, Harry James, Jan Garber, Woody Herman, and Louis Armstrong, along with others. After splitting, Tommy and Jimmy Dorsey both played separate venues at Sunnybrook for years. Starting out, a new artist named Frank Sinatra performed at Sunnybrook, working under Tommy Dorsey.

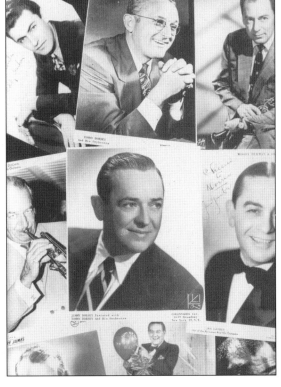

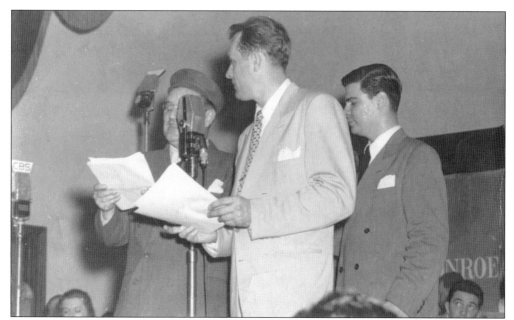

Over the years, Sunnybrook hosted a number of nationwide broadcasts for live radio shows. Not only could people attend the dances there, but they could also listen to the radio broadcast. This coast-to-coast event was for the *Camel Caravan Radio Show*. At the microphone, the host of the event, bandleader Vaughn Monroe (right), performs a skit with Colonel Lemuel Q. Stoopnagel, a zany comedian persona of the era.

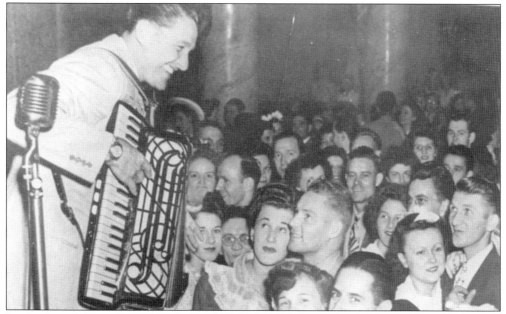

In the late 1940s, a new somewhat unknown bandleader performed at Sunnybrook with his accordion. Taking a chance on his polka type of big band sounds, the owners booked Lawrence Welk for several shows. During one of his early performances, it was said that many of the teenagers and adults did not even know who he was. Years later, Welk became a household name and had his own television show.

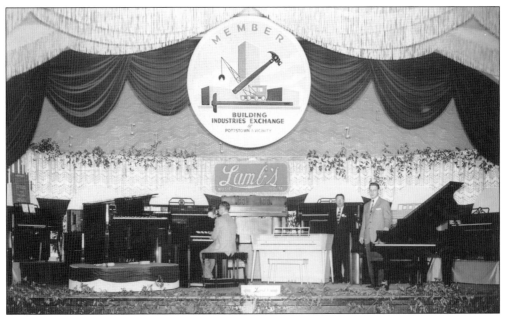

Although the big bands ruled the stage at Sunnybrook, other events were held at the famous ballroom. Such events included fashion shows, home shows, polka festivals, weddings, social events, and hundreds of dances. This picture taken in the 1950s is from the local Building Industries Exchange event held annually at Sunnybrook. Onstage that year was a display by Lamb's Music House. At the far right is William Lamb Jr.

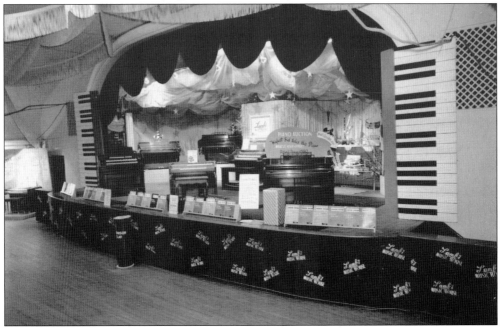

Taken several years later, this picture is of another unrelated music display from Lamb's Music House. Besides the builders' shows, Lamb's often did musical exhibits at Sunnybrook to show off the latest instruments. As a "stomping" ground for the big bands, there was no better place to show off one's new line of musical instruments.

Over the years, Sammy Kaye had come to visit Sunnybrook a dozen times. This time he entertained a gathering of Boys Scouts for a dinner banquet. Onstage with his band, during an intermission, Kaye is organizing a few vocalists and his orchestra for the performance. As a treat for the audience, this show was performed in 1942 for the *National Coca-Cola Spotlight* hour and done as a live radio broadcast.

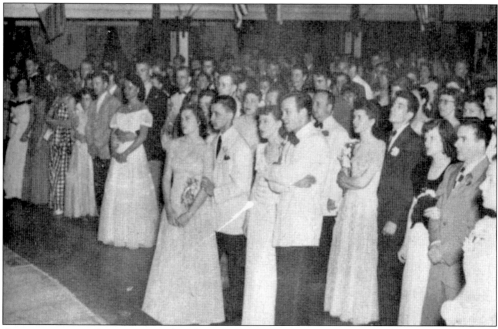

As in past years, Pottstown High School held its annual senior prom at Sunnybrook in 1948. Gathered on the dance floor, young students listen to a guest vocalist onstage during the show. Since the 1930s, Sunnybrook provided name brand entertainment for people coming from all over the Philadelphia area, and even nationwide.

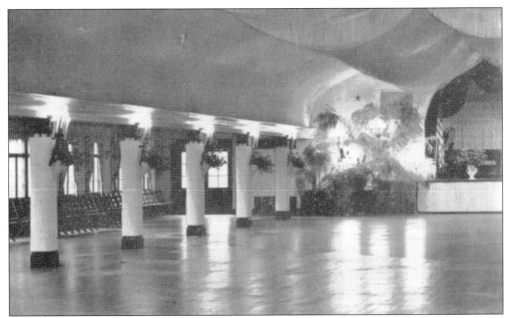

Looking toward the stage at Sunnybrook, this photograph was taken to show the alcove and additional seating areas just behind the columns on the left. The doors in the background exited out onto the swimming pool courtyard. As a bevy of stars passed through its doors, Sunnybrook became well known nationally. For more than 70 years, music in the region was best defined in three words—the Sunnybrook Ballroom.

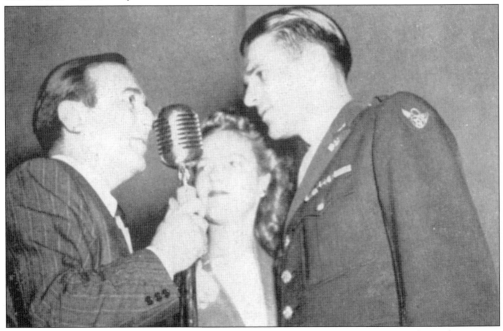

Onstage at Sunnybrook in 1946, Charlie Spivak congratulates a young newlywed couple. During a previous dance, Lt. Harold Savage proposed to his wife at Sunnybrook. Savage and his wife were called onstage by Spivak when they attended this evening's dance. This night also happened to be on their wedding night.

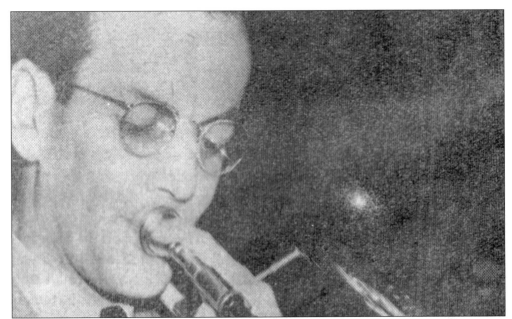

One of the most famous names to ever play Sunnybrook, Glenn Miller gave a record performance in 1942 before leaving for duty with the army during World War II. His record crowd of 7,300 people filled the ballroom while hundreds of others listened outside to say farewell to their favorite bandleader. People came from across the country to see Miller before he left for the war, never to return.

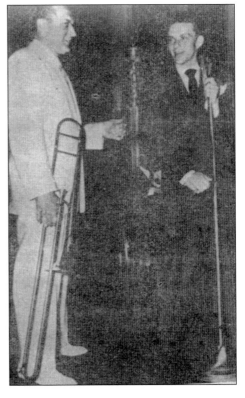

This photograph is of Tommy Dorsey at the Sunnybrook Ballroom in the 1940s. Here Dorsey introduces his newest vocalist, an unknown crooner by the name of Frank Sinatra. This rare image is one of a few remaining of the famous singer as he made only a couple appearances at the famed ballroom while his career was just beginning. Sinatra's autograph was also on the "wall of fame" behind the stage.

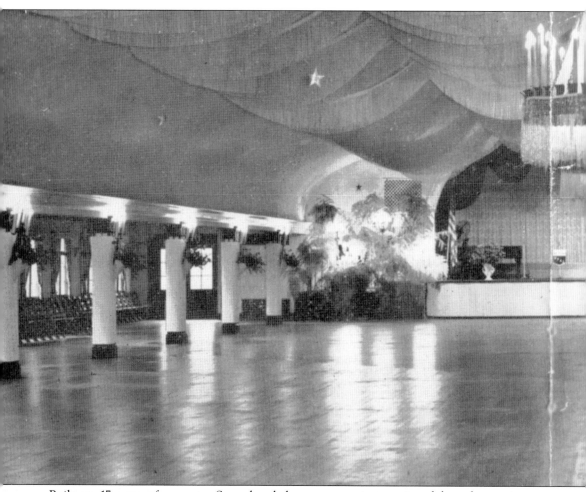

Built on 17 acres of property, Sunnybrook began as a private swim club and grew into a magnificent ballroom. The Sunnybrook Farm, where the property is located, dates back to prerevolutionary times and once included 22,377 acres of land. The ballroom and pool are located on the original tract of land, which was granted back in 1732. The Sunnybrook Farm belonged to the Kepler-Bickel families. The two daughters, Minnie Acquilla and Sara Rebecca, married

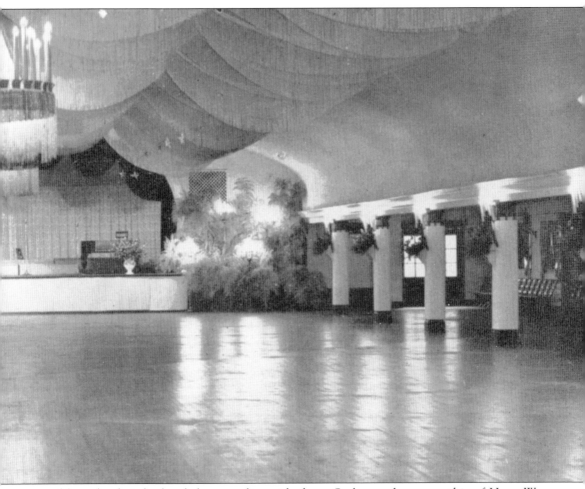

and brought their husbands home to live with them. So began the partnership of Harry W. Buchert and Raymond C. Hartenstine Sr., a simple bookkeeper and a contractor. Who would have thought all those years ago that this grand ballroom would be built on their farmland. This picture dates from May 21, 1952, when the city of Pottstown held its bicentennial ball at Sunnybrook.

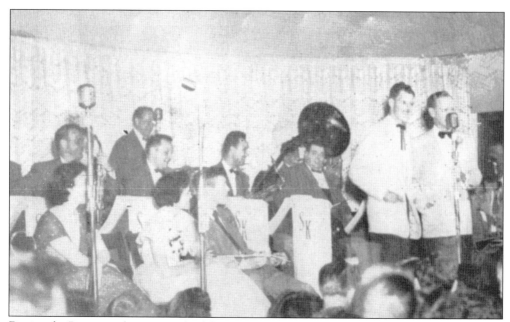

During the Pottstown bicentennial celebration in 1952, guests listened to the memorable sounds of Sammy Kaye. The event was a huge success as the Sammy Kaye Orchestra performed for the social event of the decade. Here Kaye acts out his famous "I want to lead the band" sketch with a volunteer from the audience. Kaye often brought someone onstage and gave them the opportunity to lead his band.

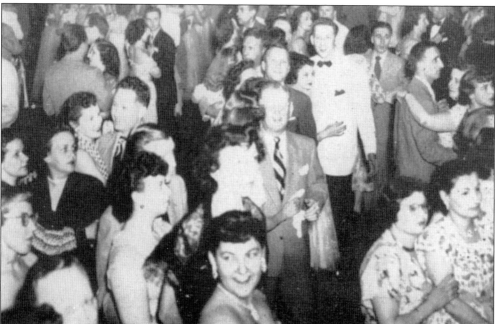

The crowd of dancers in attendance at the bicentennial ball enjoys the evening's gala event. A host of prominent citizens, local figureheads, and well-known guests mingled throughout the night as they attended the huge festivity to dance and have dinner. It was the regional social event of the year, and it was held at Sunnybrook in 1952.

Dressed in a ball gown representing the "Lady of 1752," Marty Lou Smale is crowned the bicentennial queen at Sunnybrook. The city of Pottstown celebrated its anniversary with a huge crowd. Here the burgess does the honors of placing the crown on the smiling queen. The event was a huge festivity for the town in May 1952.

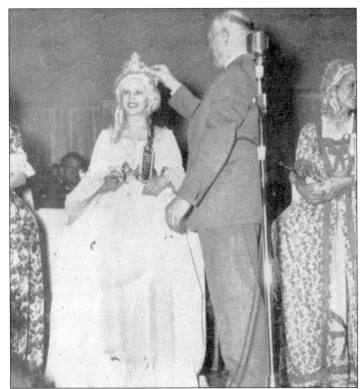

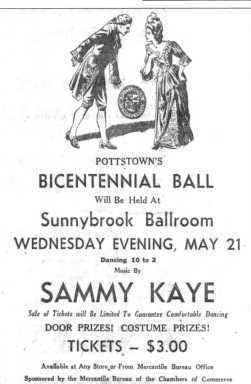

POTTSTOWN'S

BICENTENNIAL BALL

Will Be Held At

Sunnybrook Ballroom

WEDNESDAY EVENING, MAY 21

Dancing 10 to 2
Music By

SAMMY KAYE

Sale of Tickets will Be Limited To Guarantee Comfortable Dancing

DOOR PRIZES! COSTUME PRIZES!

TICKETS — $3.00

Available at Any Store or From Mercantile Bureau Office

Sponsored by the Mercantile Bureau of the Chambers of Commerce

The Pottstown Bicentennial Ball was one of the biggest and most prominent events ever held at Sunnybrook. Thousands celebrated on May 21, 1952, as they dressed in Colonial period regalia and listened to the sounds of the Sammy Kaye Orchestra. After a delicious dinner, the people danced well into the night, making it a truly historic event and a fabulously extravagant and gala ball.

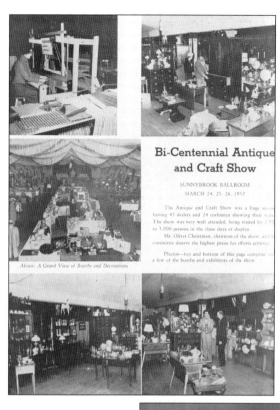

Bi-Centennial Antique and Craft Show

SUNNYBROOK BALLROOM
MARCH 24, 25, 26, 1952

The Antique and Craft Show was a huge success having 43 dealers and 24 craftsmen showing their wares. The show was very well attended, being visited by 2,500 to 3,000 persons in the three days of display.

Mr. Oliver Christman, chairman of the show, and the committee deserve the highest praise for efforts achieved.

Photos—top and bottom of this page comprise only a few of the booths and exhibitors of the show.

Above: A Grand View of Booths and Decorations

Earlier that same year, Sunnybrook was host to the Bi-Centennial Antique and Craft Show. Held in the ballroom on March 24–26, 1952, the event catered to more than 3,000 people over a three-day period. Over 40 dealers and 25 craftsmen attended and set up booths for the event. This particular advertisement from the Sunnybrook box office was also used in promoting the event throughout the region.

During the bicentennial event for Pottstown held at Sunnybrook, the Sammy Kaye Orchestra provided the entertainment. Throughout the evening, Kaye would invite local fans onstage to act as guest conductors for his band. A big thrill for any musical fan, it was part of his "I want to lead the band" segment that he did throughout the years while on tour.

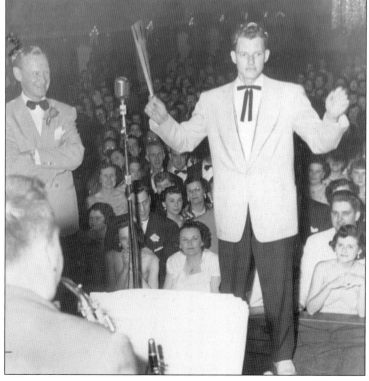

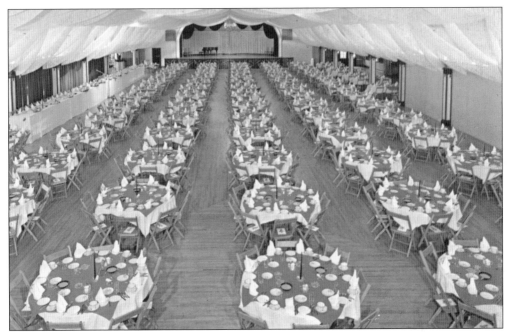

Over the years, the ballroom was configured to host a multitude of events. In a seated setting, the ballroom could accommodate up to 2,500 people for some events. At other times, standing-room-only performances would sell as many at 3,000 to 6,000 tickets for some of the big bands. Here the setting is for a special dinner event.

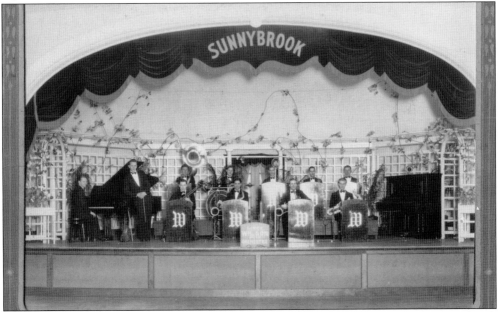

Leroy Wilson and his orchestra was one of the first so-called house bands for the Sunnybrook Ballroom. This picture, taken in 1939, comes from the collection of Norm Faut, whose brother played in the band. Standing at the piano is the bandleader Leroy Wilson. In the center of the back row is Norm's older brother Linwood Faut. The Wilson Orchestra called Sunnybrook home for several years.

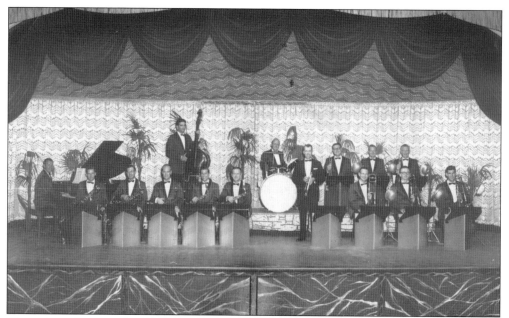

Throughout the years, local bandleader Arlen Saylor became a crowd favorite. In the Pottstown area, Saylor was a well-known celebrity. His band was originally formed as the house band for the Sunnybrook Ballroom. This early photograph shows the band in its formal years. A few years earlier, the band won first place at the American Federation of Musicians event and from there history was made.

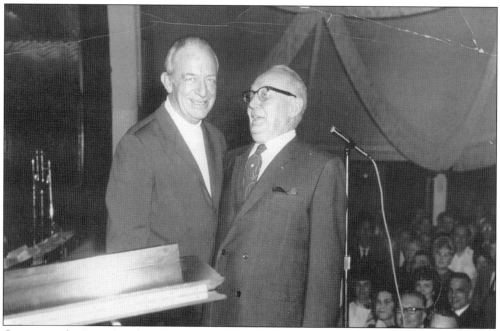

Onstage at the Sunnybrook Ballroom in the late 1950s is Harry James (left) accompanied by the Sunnybrook owner Raymond C. Hartenstine Sr. After his partner had sold the other half of the business to him, Hartenstine continued to run the facility until his passing. After introducing James to the crowd, Hartenstine poses with him for a photograph before the show begins.

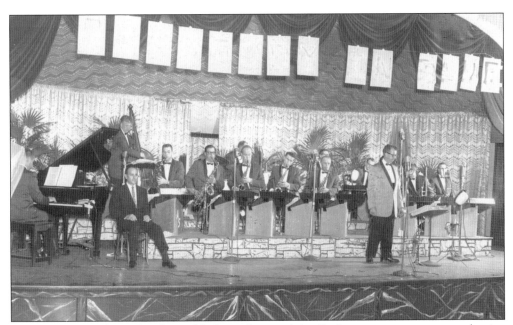

After creating the house band sound for his orchestra, Arlen Saylor spent numerous years pleasing the local crowds at Sunnybrook. He and the owners became very good friends. In the beginning, though, times were tough for Saylor's band. In order to purchase matching outfits for his group, Saylor sold his own prized gun collection. After a few years, Saylor's orchestra was recognized as the "nation's top new dance band" by the American Federation of Musicians. Saylor was a band director for years at a local high school, and it was his love of music that ignited his career. While serving in the army, Saylor performed solos at Carnegie Hall, Arlington National Cemetery, and for Pres. Dwight D. Eisenhower's inauguration. The photograph above is from a "Rhapsody in Blue" concert while the image below is from a local aloha dance, both held at Sunnybrook.

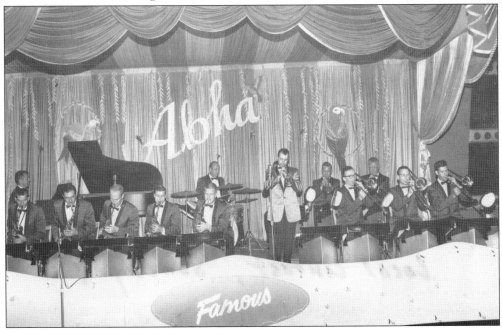

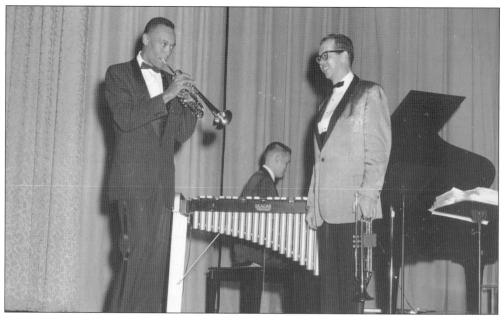

During many of his various performances, Arlen Saylor would invite guest musicians to share the stage with his orchestra. Here is a photograph of Saylor (right) with guest trumpeter Tommy Simms. Always one to perform himself, Saylor stands by watching his guest entertain the crowd. Over the years, Saylor and his orchestra performed hundreds of times at the Sunnybrook Ballroom.

Along with numerous guest musicians, Saylor would also host guest vocalists from around the country. Playing throughout the nation for large crowds, and up and down the East Coast, Saylor always called Sunnybrook home. Here guest vocalist Ray Pace sings for the crowd during one of the many yearly events at the ballroom.

Some enthusiastic fans find themselves backstage as Tommy Dorsey signs autographs at Sunnybrook. Three excited fans, from left to right, Joan Glover, Bill Seveille, and Tommy Reidenouer, were snapped by photographer J. P. Jones. The ballroom owners had a great relation with many of the big bands, calling many of them special friends. Often enough at Sunnybrook, one could personally talk with the famous bandleaders and get autographs and pictures of the celebrities.

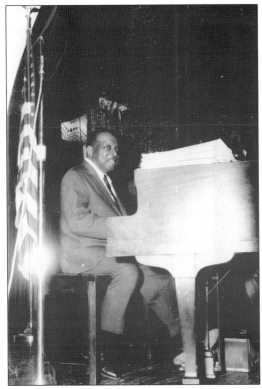

During one of his several performances at Sunnybrook, one could find Count Basie sitting at the piano. Touring from city to city, such performers would stop on their way from New York or Philadelphia and play a few gigs at Sunnybrook. Count Basie always drew a great crowd when he booked a show at Sunnybrook.

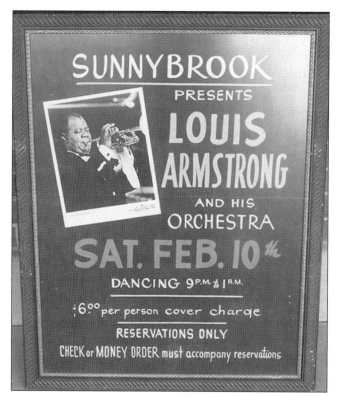

On Saturday, February 10, Louis Armstrong and his orchestra performed again at Sunnybrook. Over the years, he too had made a dozen stops at the wonderful ballroom. Throughout his career, he was a local favorite when he came to town, filling the ballroom with dancers. This poster, pictured here outside the box office, was saved and is now a valuable collector's item in today's musical marketplace.

This photograph of Armstrong was taken onstage at Sunnybrook in 1971. It is noted as one of Satchmo's last public performances. A few weeks later, he did a television appearance and a show in New York. However, on July 6, 1971, after his concert in New York, Armstrong passed away. Always a favorite at Sunnybrook, he was dearly missed.

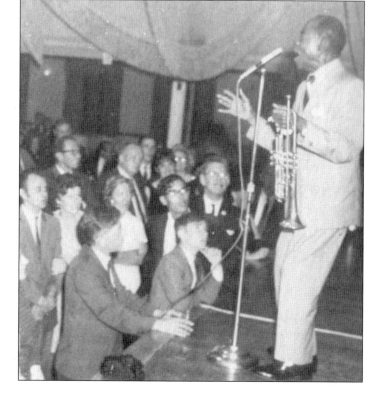

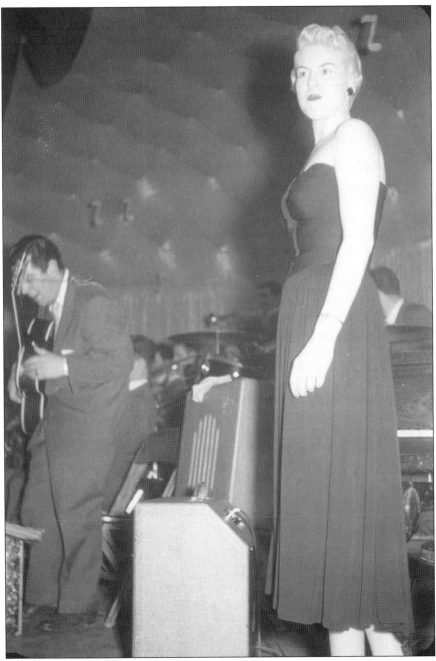

In 1952, the beautiful June Christy performed at the Sunnybrook Ballroom for the last time. This was one of the last performances from Christy while she was with Stan Kenton, prior to beginning a solo endeavor a few months later. Appearing as the vocalist for Kenton, she was one of a dozen of stunning singers of that era to grace the ballroom. Christy was an American jazz singer and highly popular during the 1950s. Christy was the vocalist for the million-selling *Tampico* in 1945, which was Kenton's biggest-selling record. Christy joined Kenton's orchestra after his previous singer left to pursue a solo career. Later in 1952, Christy began to work as a solo artist, recording various records throughout the remainder of her career.

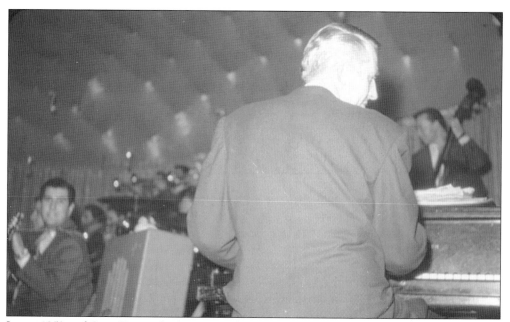

It was 1952 and Stan Kenton had come to play the fabulous Sunnybrook Ballroom for a crowd of nearly 1,000 people. One of the favorites at Sunnybrook, Kenton and his orchestras made several appearances until his death in 1979. Here Kenton is seated at the Sunnybrook house piano onstage with his band. A great entertainer, Kenton was popular among the local crowds as well as the ballroom owners.

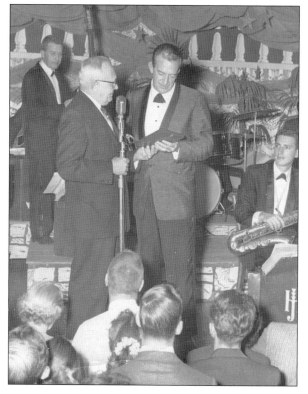

In the 1950s, Sunnybrook owner and cofounder Raymond C. Hartenstine Sr. gives guest performer Harry James an award for his efforts as a musician and bandleader. It was known that James and Hartenstine were good personal friends. Hartenstine befriended many big band leaders over the years and became a friend to most. Sunnybrook was often called the "leisure time capital of the east" by the big bands.

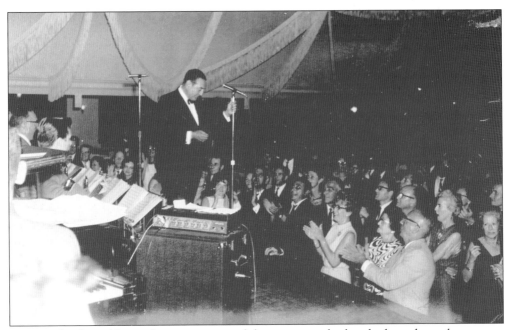

Guy Lombardo and his orchestra was one of the more popular bands throughout the years to visit the Sunnybrook Ballroom. Lombardo visited the ballroom for numerous shows and was a crowd favorite, always mixing it up with the people. Here Lombardo stands at the microphone ready to introduce the next number to his eager listeners.

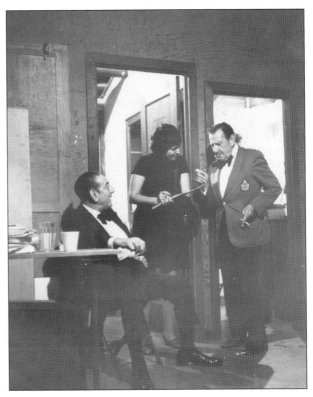

Relaxing for a moment backstage at Sunnybrook with one of his Canadian band members and a show director, Lombardo sits waiting for the show to begin. This picture, taken outside one of the dressing rooms, also captures many of the autographs and drawings behind Lombardo on the "wall of fame" just behind the Sunnybrook stage. For years, the stars wrote their names on the wall when they visited.

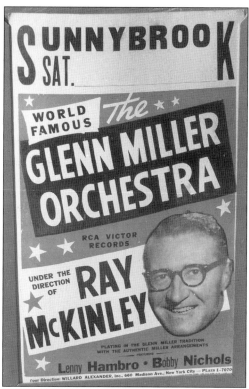

Taking over for Glenn Miller after his untimely death at the end of World War II, Ray McKinley now leads the orchestra. Miller holds the record attendance at Sunnybrook with over 7,300 people for a performance with hundreds more standing outside. Before leaving for the war in 1942 with the army, Miller did a final show at Sunnybrook. People came from across the country to see him one last time.

In the later years, the big band sound would fade, but Sunnybrook kept it alive with continuing performances. For a few years during the war, Sunnybrook had lost most of the big bands, which had now joined the USO and were touring overseas. In that time, the owners closed the ballroom for a couple years. In 1945, the ballroom reopened, and big band music played again.

Onstage at the Sunnybrook Ballroom from left to right are Doris (Hartenstine) Drumheller, Ray Hartenstine Jr., Harry James, and Robert Hartenstine. Taken in the mid-1970s, James was still visiting his friends at Sunnybrook to perform on various occasions. As he was with their father before them, James was a friend and frequent guest of the family and continued to bring his big band sound to his fans.

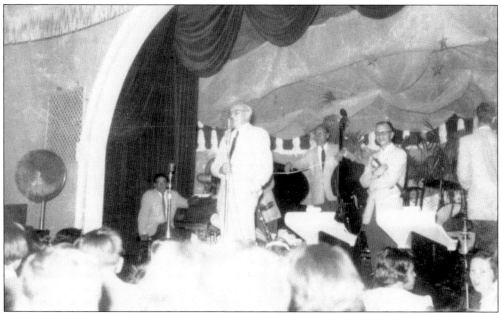

In the late 1940s, Raymond C. Hartenstine Sr. speaks to a crowd of listeners before a big band concert. In those days, large fans like that seen to the left were often used to cool the huge crowds in the years before air-conditioning. Often the temperatures became so hot inside the ballroom, where thousands would gather to hear an orchestra play, that some people were taken out sick and overheated.

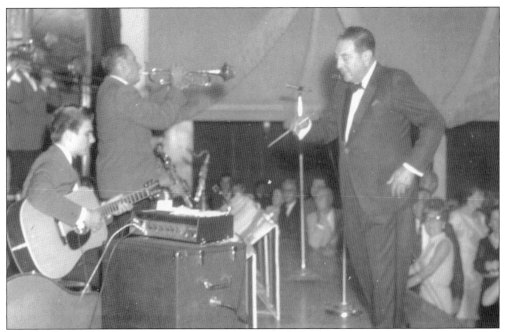

The "Maestro of Nostalgia" takes the stage, as Guy Lombardo directs his orchestra for the evening dance at Sunnybrook. Accompanying his usual big band orchestra, one now finds an amplified acoustic guitar playing as part of his band. Over the years, Lombardo adapted his musical performance to incorporate the more modern sounds.

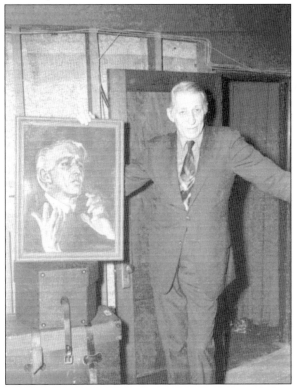

Backstage at the Sunnybrook Ballroom, Stan Kenton poses with a portrait given to him as a gift. With three small dressing rooms backstage, the area was not big enough for all band members to dress at once. This is a rare glimpse into the scene behind the curtains at the famous ballroom. This picture was taken in the late 1950s, as Kenton had been visiting Sunnybrook for over a decade.

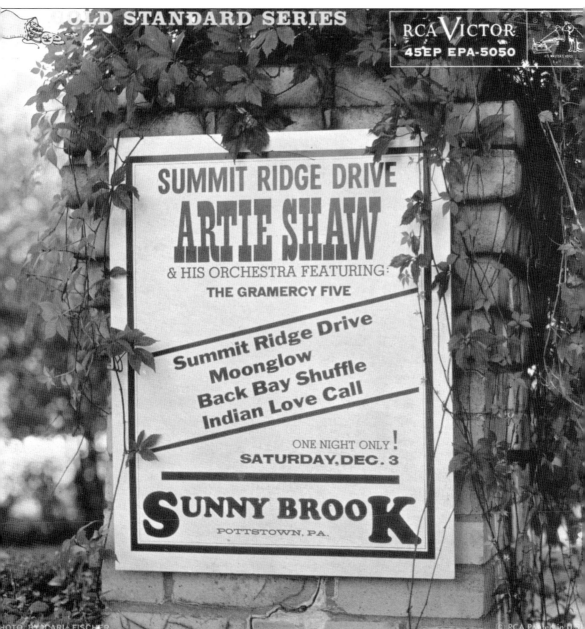

Sunnybrook was nationally famous with the big bands, and when Artie Shaw and his orchestra put a mock Sunnybrook poster on an album cover it drew even more attention from the public. This was a small 45 record that contained four of Shaw's most popular songs at the time. Made to look like a poster from the Sunnybrook Ballroom, the colorized print was produced for the album jacket. The image of this poster was actually photographed at the Sunnybrook pool, where it hung on a vine-covered pillar that held up the trellises that were located beside the swimming area and just outside the famous ballroom. The use of the poster and the Sunnybrook name brought the ballroom even more recognition as the "Entertainment Capital of the East." It was done as a promotional item and was even given away at concerts when Shaw and his bands returned to Sunnybrook.

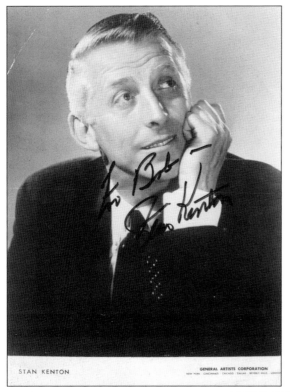

STAN KENTON GENERAL ARTISTS CORPORATION
NEW YORK · CINCINNATI · CHICAGO · DALLAS · BEVERLY HILLS · LONDON

This is a personally signed promotional photograph of big band leader Stan Kenton. Over the years, hundreds of promotional pictures just like this one, which were given out by the agents and booking companies, graced the ballroom's back walls and dressing rooms. This autographed print was signed for Robert (Bob) Hartenstine by Kenton on one his many visits to the Sunnybrook Ballroom and remains in the family collection.

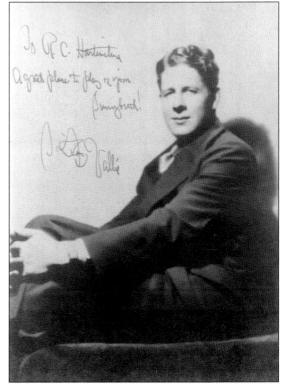

From the personal collection of the Hartenstine family is a signed picture of Rudy Vallie that was given to Raymond C. Hartenstine Sr. in the 1930s after a performance. The family collection of promotional photographs included various signed pictures and other memorabilia. Besides the "wall of fame" that was signed by each band behind the stage, the dressing rooms and offices of the ballroom housed many valuable mementos from the era.

Four

Modern-Day Sunnybrook

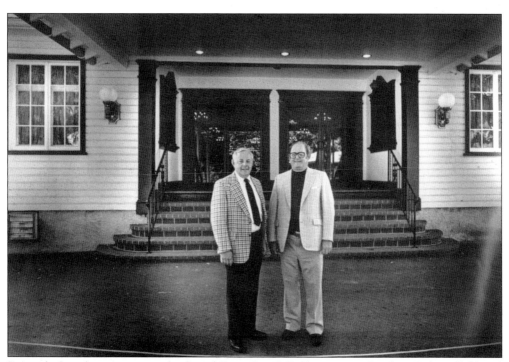

Posing before the entrance to the famed Sunnybrook Ballroom, twin brothers Robert (left) and Ray Hartenstine smile for the cameras. Along with their older sister, Doris, the brothers took over ownership of the facility after their father's passing in 1972. The brothers were born on December 7, 1929, and were seven years younger than their sister. Together they managed the ballroom for many years. Eventually Sunnybrook was sold in April 1998.

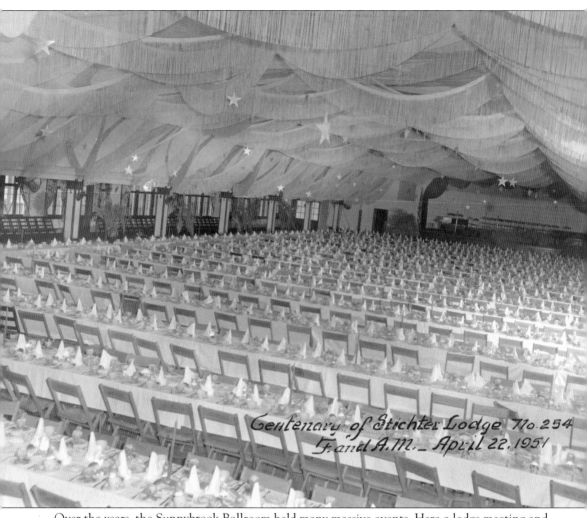

Centenary of Stichter Lodge No. 254
F. and A. M. — April 22, 1951

Over the years, the Sunnybrook Ballroom held many massive events. Here a lodge meeting and dinner is dated April 22, 1951. Depending on the events, the ballroom could accommodate thousands of people. There were various seating arrangements that were outlined and done for each event by the staff. In a setting such as this one, where there is side-by-side seating in vast rows, it could seat a little more than 3,000 people for a large dinner event. Often throughout the years, it would hold triple that number for dance events and big band concerts when the owners would utilize a standing-room-only venue for the patrons. The record attendance was over 7,300 people for Glenn Miller's final concert. Upon several other occasions, the ballroom also held 6,000 or more for other popular shows that would come to town.

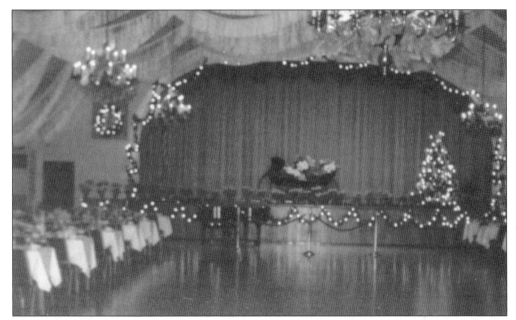

At the far end of the ballroom, opposite the entrance, the stage was also decorated for the annual Christmas events. With a tree, or sometimes two, placed onstage, the ballroom was ablaze with lights. Often a horse-drawn sleigh was centered onstage and covered with garland and ornaments. Another one of the family antiques, it was used for special occasions such as this.

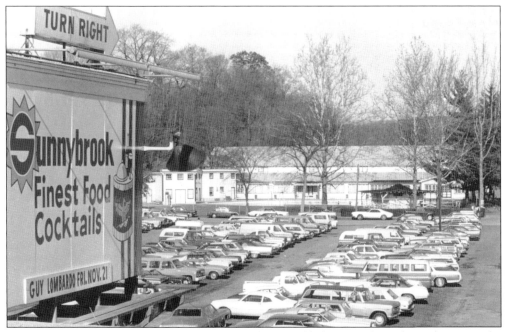

In the early 1970s, Sunnybrook was still a bustling establishment. Throughout the years, the parking lot remained packed during the weekends. The lot itself held between 800 and 1,000 cars depending upon the event. Here people are arriving for a Guy Lombardo concert that evening, as advertised on the billboard at the High Street Bridge.

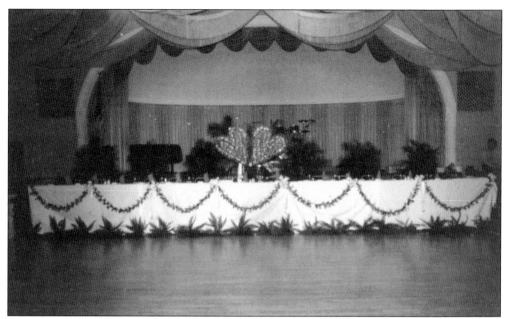

As with every special holiday event, Sunnybrook's owners decorated the grand ballroom accordingly. Traditionally the biggest events over the years, besides the massive swing dances, were Christmas, Mother's Day, Fourth of July, and of course, every couple's favorite—Valentine's Day. Here a display of hearts takes center stage as the ballroom prepares for another long and enjoyable evening filled with music, dinner, and dance.

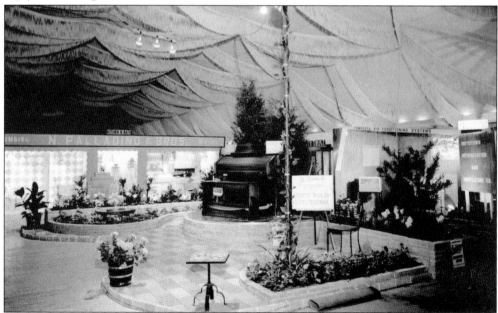

Between the usual big band performance and tour engagements, Sunnybrook still hosted a number of local events such as weddings, proms, social galas, society dances, business expositions, and various trade shows. In this particular photograph, Sunnybrook is set up for a local trade show that often had 50 to 100 exhibitors. Catering to the local businesses, Sunnybrook hosted such shows for more than 50 years.

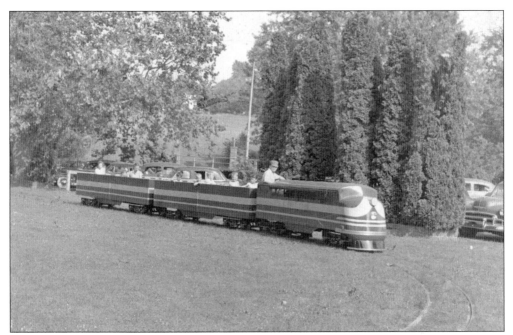

At the edge of the parking lot, the *Sunnybrook Limited* rounds a corner to begin its run back to the station. The train's route at Sunnybrook took it along the creek, toward the parking lot, and back around to the large picnic pavilion. The train often ran with two to four cars in tow behind it.

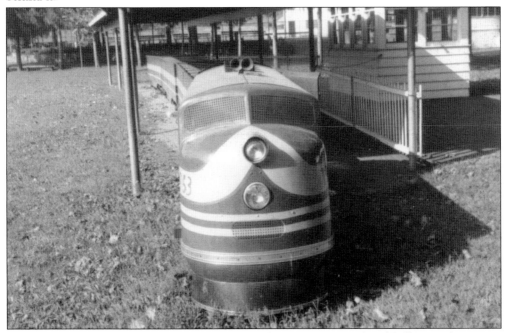

In the lower gardens of Sunnybrook, across from the swimming pool and ballroom, the owners had installed a small-scale railroad train. Guests at Sunnybrook, complete with its own train station, could enjoy the pool and later enjoy a ride around the lot on the train. Here the train sits waiting beneath the old covered station that was built especially for the train and its cars.

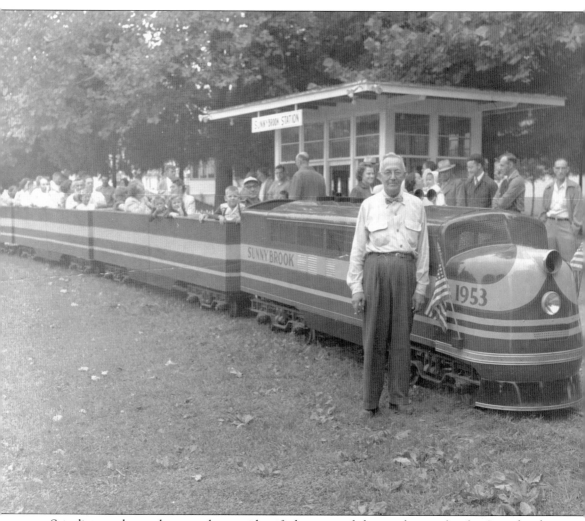

Standing at the ready, a gentleman, identified as one of the conductors for the *Sunnybrook Limited*, waits as the eager children and their parents board the train for a ride around the lower gardens. The *Sunnybrook Limited*, as it was known, had an engine and four additional passenger cars. Most of the time during the week, the train ran with only two cars, but on busy weekends, the four-passenger cars were fully used. Installed at Sunnybrook in 1953, the train ran for years until the mid-1960s when it was dismantled and sold. The train, complete with engine, passenger cars, and tracks and equipment, was sold for a mere $2,500. It was a novelty idea that the owners thought their visitors would also enjoy, and it had a good run at Sunnybrook over the years. After the train was removed, the lower gardens became additional parking for the pool area, until being converted to a parklike setting, complete with landscaping and sporting courts in the 1980s.

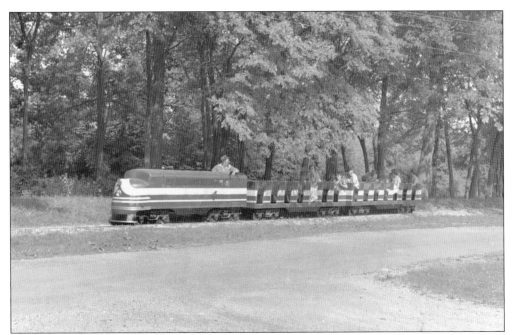

From the train station to the parking lot and around the lower gardens, the *Sunnybrook Limited* steamed along. The track was about 100 yards around and built in a large oval. Here the *Sunnybrook Limited* passes along the edge of Sprogel's Run Creek, which runs along the eastern border of the Sunnybrook property and the lower parking lots.

This photograph from the mid-1980s is of the lower garden area where the *Sunnybrook Limited* train once made its daily runs. After the train was removed and the area became a parking lot, it was converted into a parklike setting with volleyball and basketball courts. Originally there was a catwalk bridge, from the swimming pool area, over the road, to the gardens that fronted the large picnic pavilion.

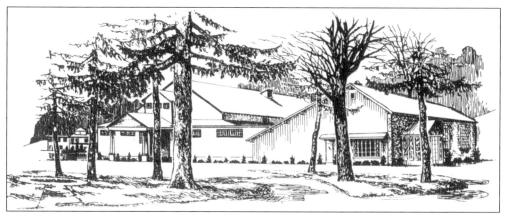

A sketched drawing from the 1960s shows the newly remodeled Sunnybrook facility. This image looks west along the buildings. To the right is the new Colonial Inn and Tavern (later simplified to the Colonial Room), at center is the massive ballroom structure, and to the far left in the background is the pool house. This image was used on letterhead, memorandums, and newsletters published by the owners.

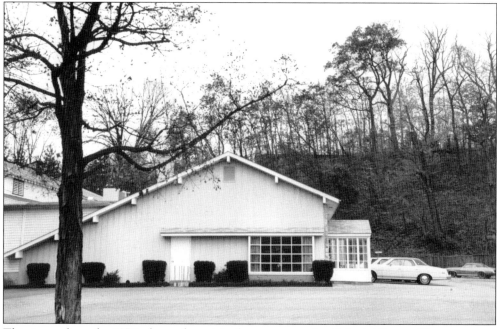

This image from the 1970s shows the original entrance to the Colonial Room. The restaurant addition was built in 1963 and was connected to the ballroom to the left of this photograph. Like its predecessor, the Colonial Room was a wood frame building. Between the ballroom and restaurant were the tavern area and "combo" rooms that could be opened to the ballroom to accommodate additional groups.

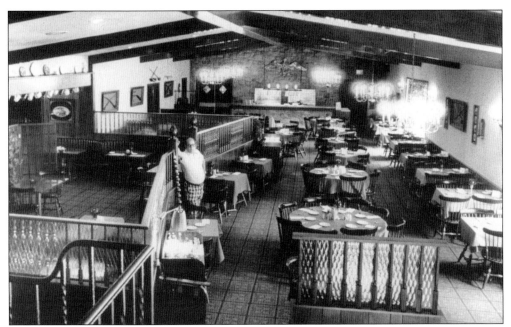

Standing in the center of the Colonial Room, Ray Hartenstine Jr. poses for a picture. Taken from the sitting area above the entrance, this panorama shows the expansive dining area of the restaurant as well as the many antique decorations that adorned its walls. To the left of the restaurant area is the alcove leading into the tavern and barroom. Beyond the tavern is the massive Sunnybrook Ballroom.

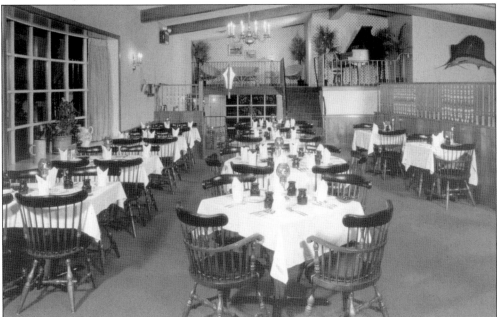

Peering out over an empty restaurant, this photograph shows the entrance of the Colonial Room. Open evenings for dinner, the tables are set and ready for the coming crowd. Located in the sitting area above the restaurant, the piano from the stage is visible in the right corner. This piano was moved often from the inn to the tavern, and back to the stage for use during concerts.

SUNNYBROOK NEWS

Published periodically from somewhere inside Sunnybrook.

Fall-Winter, 1974

Happiness Is a Sunnybrook Holiday

Arlen Saylor's House Band Is Success Story

To the Pottstown area, being without Arlen Saylor is like being deaf to music and throwing the whole world off key.

Saylor formed Sunnybrook's first and only "house band" in the summer of 1960 and the success story, one of the few of its kind, was almost immediate.

In it's infancy, it won a big band contest sponsored by the American Federation of Musicians and it was the band's first public appearance at the Famous Ballroom in Baltimore, Md. The band returned home after capturing the musician's

Sunnybrook always draws a packed house for its New Year's Eve party and anyone who fails to make early reservations, will have to skip it for another year.

But those who do manage to make the party scene know what the others have missed. The evening starts with a full course prime rib of beef dinner. Champagne tops off the meal. In addition hats and novelties are provided and the music will be continuous throughout the evening. The charge is $45 per couple.

There are many reasons for the success of New Year's Eve at Sunnybrook and two very good ones are Arlen Saylor and Guy Greco and their orchestras.

Profiles of these talented and dedicated leaders are at left and right.

Greco Manages To Keep in Tune With Challenges

If a musician's life and ambitions were as easy to keep in tune as his music, he probably would be looking to another medium for challenges.

To a fellow like Guy Greco, this seems to be what motivates. And the more challenges he's faced, the better he's become.

But no matter how you look at it, Sunnybrook Ballroom has played a large part in his efforts and the band's popularity, Greco admits.

"The boys will tell you, they played the shore resorts, mountains, big hotels in Philadelphia,

The *Sunnybrook News* was a self-published newspaper created by the owners of the facility. For years, the newspaper was available on-site at the pool house or restaurant. The newspaper would often include historic articles about Sunnybrook as well as a list of upcoming events. The newspaper was published each quarter. This issue is from fall-winter 1974. Eventually the newspaper became a small brochure-size pamphlet.

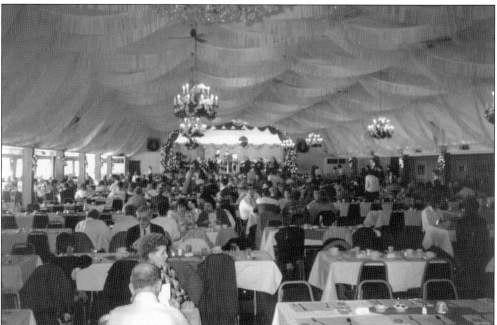

Playing to a packed ballroom, a band takes the stage at the front of Sunnybrook. While hungry people made their way through the buffet lines for a seasonal event, they were always entertained by music. A setting like this could accommodate over 1,000 guests. High overhead, the decorative streamers and massive chandeliers create an ominous setting as they are lit for the event.

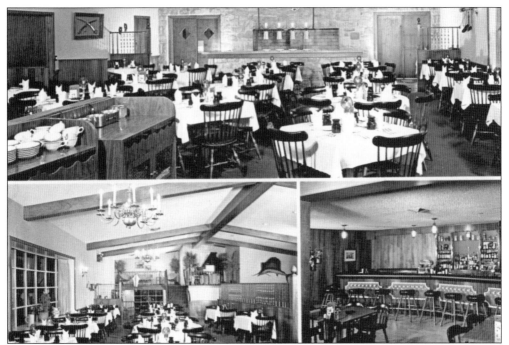

In 1963, the Hartenstines added a restaurant to the Sunnybrook Ballroom. Originally named the Colonial Inn and Tavern, it was decorated with antique collectibles from the Colonial era. The Colonial Inn was a busy place on weekends, when people would have dinner right before buying a ticket and listening to bands perform in the adjacent ballroom. The Colonial Inn restaurant also included a weekend buffet and a bar.

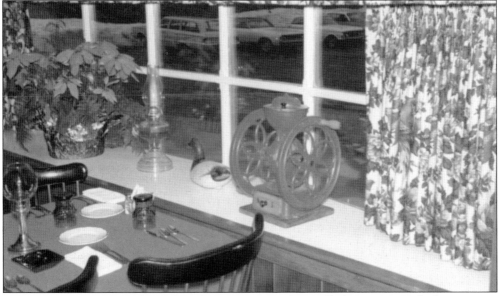

Filled with antique items, the Colonial Room, as it was later called, was a quaint little restaurant and a welcome addition to the ballroom. The modern restaurant with its up-to-date kitchen was well recognized in the region for its style and cuisine. Here an old coffee grinder sits along the window sill with some other collectible items.

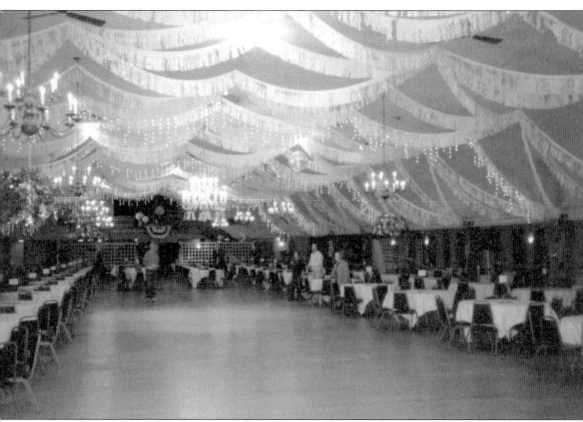

Decorated for a dinner event, the Sunnybrook Ballroom is shown in all its glory. The big band names had all played here over the years, including Artie Shaw, Kay Kyser, Sammy Kaye, Vaughn Monroe, and countless others. Now as a new generation of fans was growing up on rock-and-roll music, the dances also had come to change. In 1937, Sunnybrook had been nationally recognized in *Life* magazine when Hal Kemp played here for the "Life Goes to a Party" series. Over the years, the nostalgia had faded, but the sounds of music still echoed in the magnificent ballroom. People nationwide still know the name Sunnybrook.

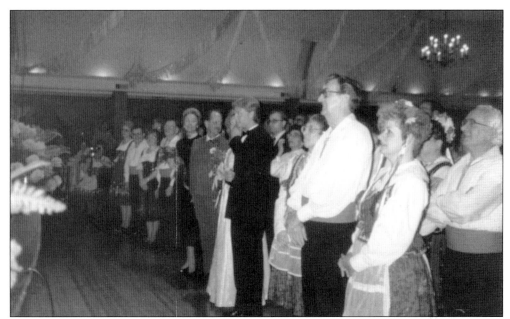

On hundreds of occasions, Sunnybrook's glamorous ballroom hosted wedding events and receptions. With one of the largest dance floors on the East Coast, Sunnybrook could easily hold massive crowds for a wedding reception. Over the years, hundreds of couples have created fond memories of their special day at Sunnybrook. Here an ethnic wedding reception is caught on camera as the guests listen to a band onstage.

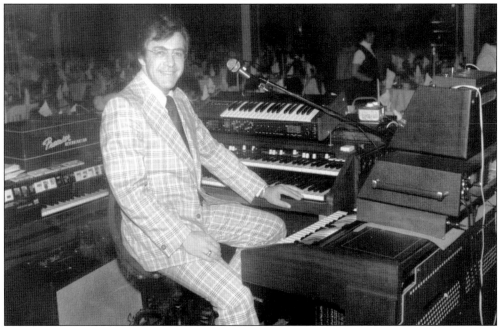

Local celebrity entertainer Ron Dell plays for a crowd at the Sunnybrook Ballroom. Dell would often provide the evening's music for guests in the ballroom or the tavern during weeknights and weekends. His electronic organs and synthesizer system were said to have cost Dell over $18,000 and took two years to build.

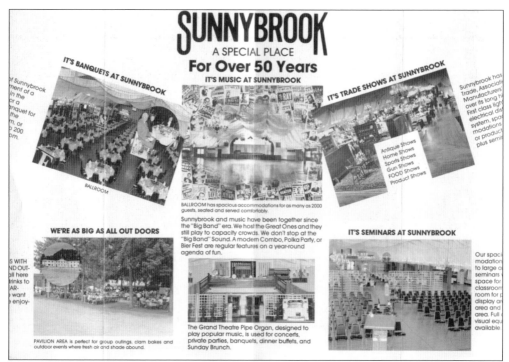

This is one of the most recognizable brochures from Sunnybrook. A local landmark for over 50 years, Sunnybrook catered to musical fans, housed polka festivals and trade shows, and also served up dinner in the Colonial Room restaurant. On 17 acres of property, Sunnybrook became a community symbol that could host seminars indoors as well as picnic events outdoors.

Presenting an award to their friends, Ray Hartenstine Jr. (second from left) and his brother, Robert Hartenstine (far right), are seen standing at the podium before the ballroom stage. For years, the family farm had provided dairy milk to other farms, most notably Meadowbrook Farms, which also ran an ice-cream stand. Here the Swavleys accept a silver bowl at the presentation.

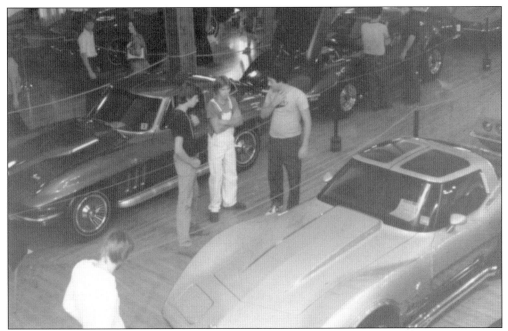

In later years, between the musical venues that still played Sunnybrook, the ballroom also came to host various other events. A picture here shows an automobile show that was held inside the ballroom. This Corvette car show was one of a few held here. Afraid of damaging the ballroom floor, such shows were limited as time passed.

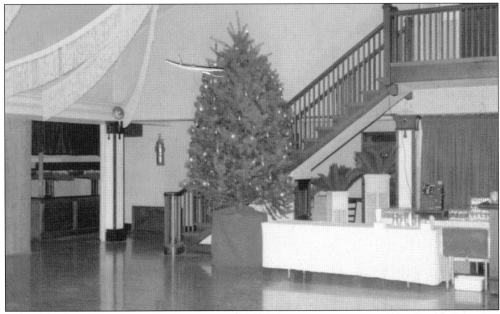

Setting up for Christmas holiday dances was always a big undertaking at Sunnybrook. Before all the other decorations were put into place, several Christmas trees would be brought in and set up around the ballroom and dance floor. This tree is near the main entrance of the ballroom. Years later an antique pipe organ would be mounted in the building at the top of the steps seen here.

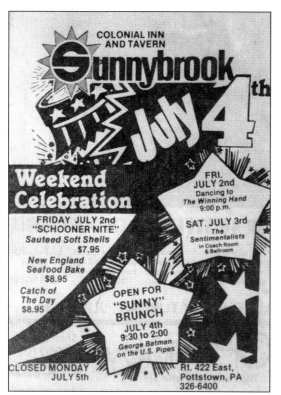

This is an advertisement for both the Sunnybrook Ballroom and the Colonial Inn and Tavern from a past Fourth of July. It was a full weekend-long celebration with dance bands booked for Friday and Saturday. On the holiday itself, Sunnybrook also held its Sunny brunch with organ music to dine by. After a long weekend, Sunnybrook could recuperate on Monday when it was closed for the day.

Over the years, Sunnybrook utilized all its assets to provide a variety of events for its guests. This photograph from the 1970s was taken during one of the many polka festivals that were now being held in the ballroom. To accommodate all types of taste in music, Sunnybrook also put on beer festivals and other musical numbers in the years after the big band era.

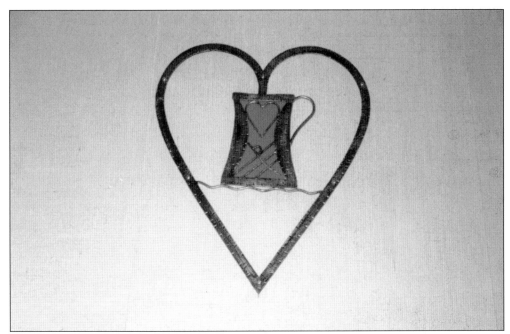

Mounted on the wall in the Colonial Room was this metallic heart logo. Inside the heart is a beer stein with another smaller heart carved inside of that. Some say this was made for the Hartenstine family as an emblem. It is a "heart-in-stein" mounted inside of another heart. For years this hung in the restaurant as a reminder of the family who built Sunnybrook.

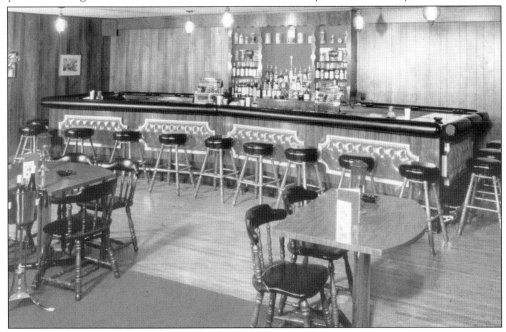

The tavern area of the Colonial Room had extra tables for the bar visitors and a full-service bar that sat 15 people. Surrounding the bar, wooden floors were used so that the tables and chairs could be moved to provide additional dance space for patrons on weekends. At the far end of the bar area, walls could be moved, opening up even more area to the larger ballroom.

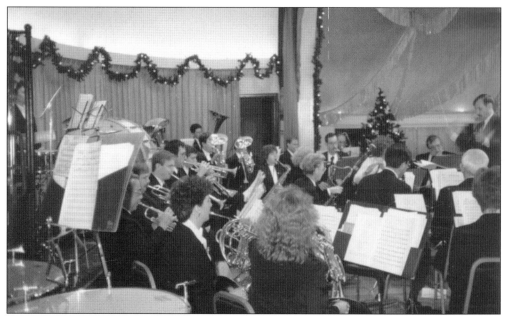

As Sunnybrook moved into the modern era, the sound of bands such as Glenn Miller, Benny Goodman, Rudy Vallie, the Dorsey Brothers, Cab Calloway, and others was replaced in part by symphony orchestras. Here a later photograph shows a local symphony orchestra during a "Pops" performance. Still the popular bands under Harry James, Buddy Rich, and Count Basie would make the occasional stop at the ballroom.

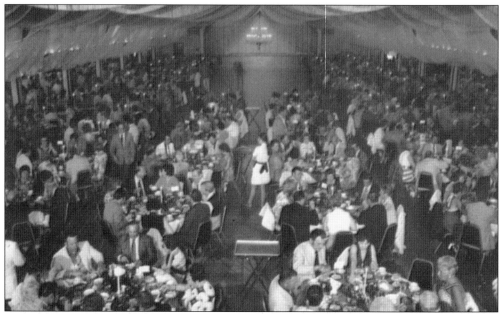

Taken from above the ballroom floor, this image shows Sunnybrook at its busiest. Open for dinner, the ballroom also accommodated the usual weekend brunch. As the brunch grew over the years, the restaurant became too small to hold everyone. Opening the ballroom, the staff could serve hundreds for a Saturday or Sunday brunch. On one occasion over 1,000 people came to the ballroom for a Mother's Day dinner.

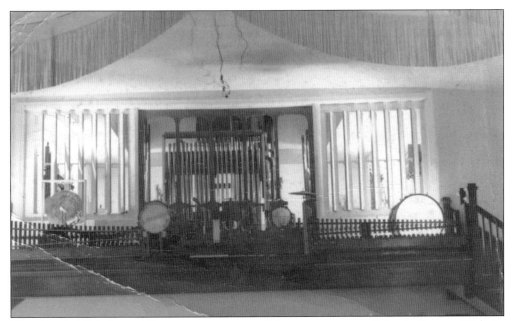

The famed 1928 Opus 101 pipe organ is a well-known treasure of the ballroom. With its perfect acoustic surroundings, the Sunnybrook Ballroom was a natural home for the organ. Installed in 1981 to celebrate Sunnybrook's 50th anniversary, the U.S. Theatre Pipe Organ is a magnificent sight to behold. Originally built to accompany silent films, the organ was set in the Lansdale Theatre until 1942. At the time, the organ was moved to a church and its whimsical trappings—whistles, gongs, and drums—were stripped and stored in a separate garage for 30 years. In 1971, Roger and Dorothy Bloom saved the organ from destruction and had it painstakingly refurbished. The organ was bought and installed at the ballroom for Sunnybrook's anniversary, and it still remains today.

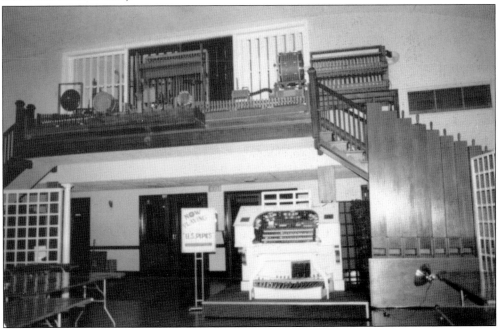

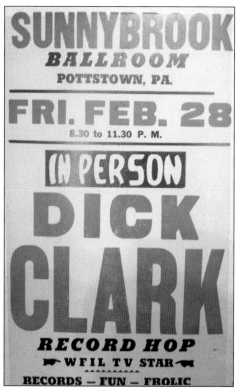

This original poster from a dance at the Sunnybrook Ballroom was on display in the tavern. In the 1950s and 1960s, Dick Clark made three appearances at the Sunnybrook stage for several record hops, as they were known. Promoting various shows in Philadelphia and *Bandstand*, Clark hosted these events in the massive ballroom. Because of the size and acoustics of the building, the dances were highly attended and successful.

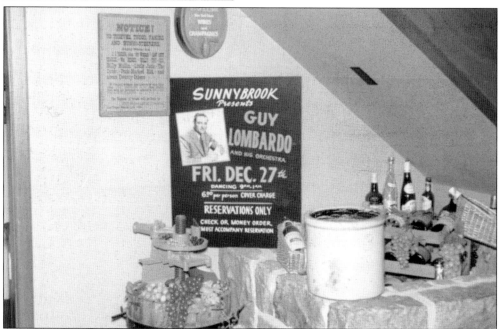

Hanging in the back room full of wine, a poster for Guy Lombardo reminds the workers of the big band era that Sunnybrook helped to cultivate. For years, even after the big bands had quieted, leaders such as Lombardo would return to Sunnybrook for special programs. The bands had gotten older and so did their fans, but the love of the swinging music never really faded.

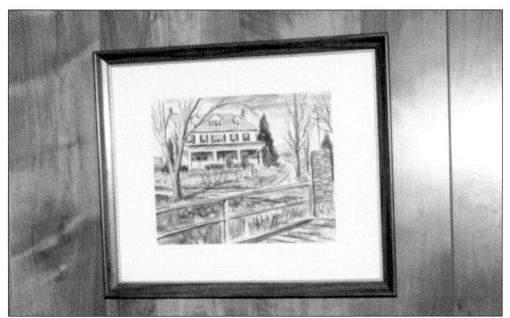

Hanging in the Colonial Room is a painted portrait of the original family farmhouse that belonged to the Kepler-Bickel family. The tract of land dated back to Colonial times and remained in the family for nearly two centuries. It was the Kepler daughters who married the original Sunnybrook founders, Raymond C. Hartenstine Sr. and Harry W. Buchert. The original family house still stands today right near Sunnybrook.

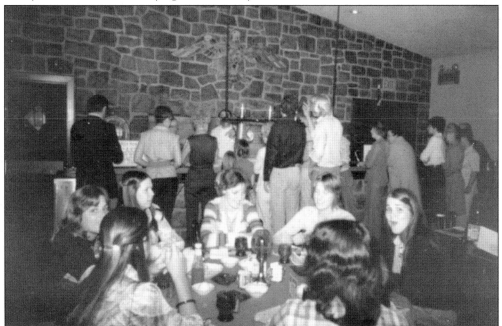

A typical Sunday brunch would fill the Colonial Room to capacity. People came from far and wide to enjoy a bevy of items and the colossal buffet. Once on Mother's Day, a crowd of over 1,000 was reported for the buffet. Often the waitstaff would have to open up the combo rooms or even sit people in the majestic ballroom to accommodate the crowds.

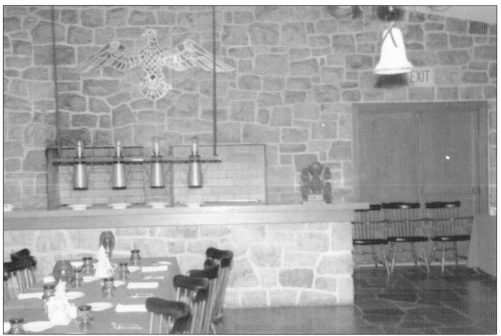

At the rear of the Colonial Room, a huge glass and lead eagle spreads its wings on the wall above the buffet serving line. Made special in Europe, this collectible piece was presented to the Sunnybrook owners. For years, it hung above hungry patrons as they dined in the restaurant.

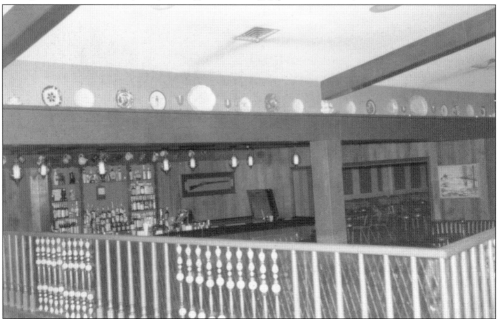

This interior view of the Colonial Room is facing toward the bar area. Bordering the room were various Colonial-era dishes and plates on the upper walls. At the back of the bar itself is an old antique rifle from the family's collection. Rumor had it the antiques were stolen, but truth is, most of the antiques were kept in the family and divided between the children and grandchildren accordingly.

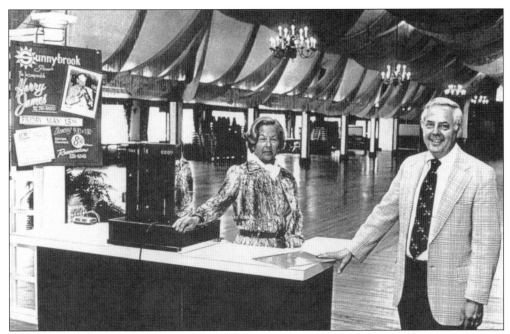

Standing at the ready, near the entrance of the ballroom, Doris (Hartenstine) Drumheller and her brother Robert Hartenstine wait at the cash register. For years, the business would stay in the family. When Harry W. Buchert retired in the 1950s, control of the business passed to Raymond C. Hartenstine Sr. When Raymond died in 1972, he left the care of Sunnybrook to his three children.

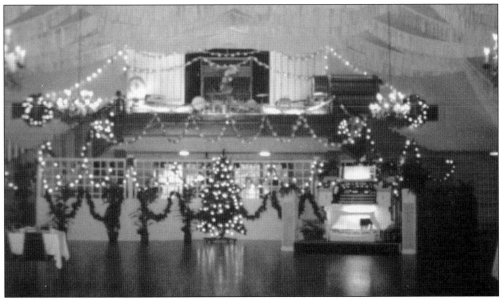

Bright lights, ornaments, and other Christmas decorations adorn the entrance of the grand ballroom at Sunnybrook. Stationed to the right, the pipe organ waits to be played for the night's dance. Throughout the ballroom, the owners would take great care in preparing for such events. The ballroom was well known for its music and also the comfortable atmosphere. It was a place where memories were created.

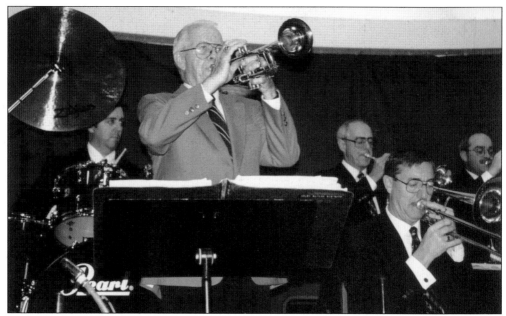

A familiar face at the Sunnybrook Ballroom makes a triumphant, or "trumpeting" return. Having performed at the ballroom for decades, Arlen Saylor and his orchestra make a return engagement for their admiring fans. A great personal friend to the owners, Saylor was, and is, a locally recognized name among the big band leaders. Today Saylor still resides in the Pottstown area and still has that passion for music.

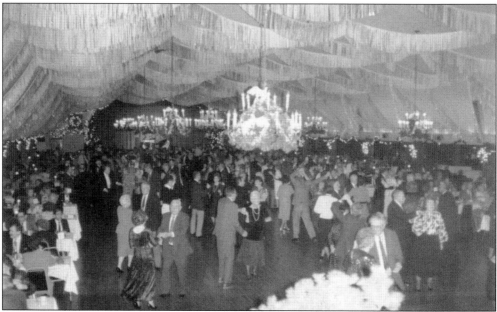

For more than 50 years, Sunnybrook has hosted annual Christmas galas. This picture from the late 1980s shows the ballroom filled with dancing couples who have come to celebrate the evening. Surrounded by the Christmas spirit, the happy couples listen to a variety of holiday music as they shuffle their feet on the imported hardwood floor. Holidays at Sunnybrook were always memorable.

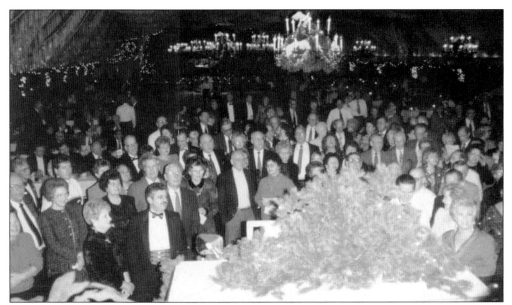

Throughout the celebration on Christmas Eve, the band would invite the happy guests to join in a Christmas carol sing-along. Gathering around the famed antique pipe organ, the cavalcade of voices would soon fill the air and project out into the night. Often the musical sounds from Sunnybrook could be heard for a few miles around town. This night, during Christmas Eve, the joyous carols filled the ballroom.

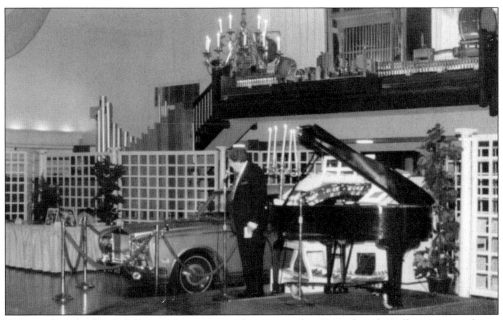

Hosting hundreds of different events over the years, the Sunnybrook Ballroom was always decorated for every occasion. Often special programs such as charity events, society galas, and business parties brought Sunnybrook alive. At the entrance to the ballroom, the famed piano from the stage sits next to the antique pipe organ. Overhead the pipes and other musical trappings are visible. Yes, for this event, someone even displayed their Rolls Royce.

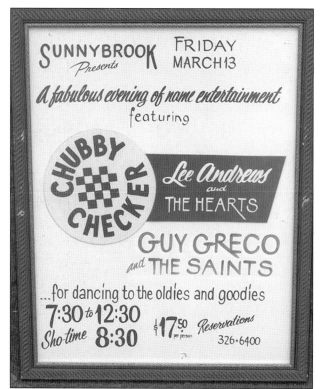

As rock and roll was introduced, Sunnybrook hosted numerous acts over the years. The first rockers to grace the stage at Sunnybrook were Bill Haley and the Comets in 1954. Mixing such bands on the ticket between big band concerts helped Sunnybrook usher in a new era. This poster from the 1970s is for Chubby Checker, who visited the ballroom on several occasions to help dancers twist the night away.

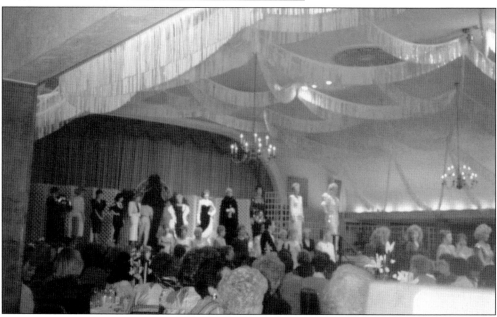

Throughout the years, between big band and rock-and-roll events, fashion shows would also adorn the stage in the ballroom. In the past, glamorous gowns and gorgeous evening dresses could be seen at the dances and at the many fashion balls. Taking the stage this evening, a bevy of local beauties shows off the latest evening wear for a special presentation hosted by a local magazine and television charity.

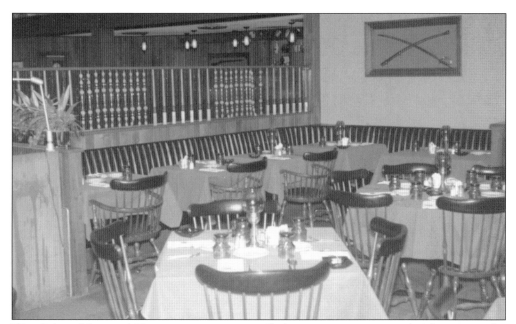

The Colonial Inn and Tavern, as it was originally known, was constructed right next to the Sunnybrook Ballroom in 1963 and opened its doors to guests. To carry on the tradition of the ballroom, small bands and solo performers would entertain people throughout the week with a variety of tunes. On Saturdays after dinner, guests could even dance in another room of the tavern.

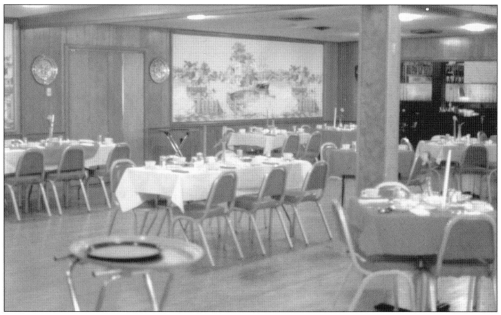

The Colonial Inn, later known as the Colonial Room, offered a diverse menu to its guests. Just through the doors, and on the other side, was what were called the combo rooms. These smaller rooms were divided from the main ballroom by movable partitions. For larger events, the partitions could be removed. On the far wall, a huge landscape painting of Colonial-era ships and homes adorned the room.

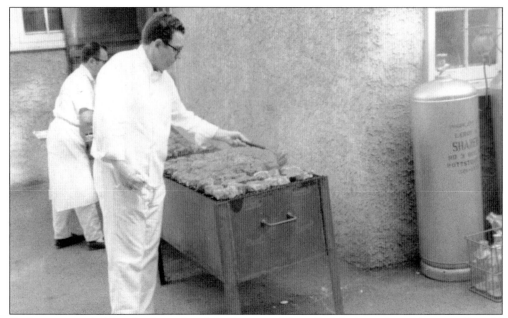

For large events held in the Sunnybrook Ballroom, a full staff of chefs, cooks, and waitstaff would tend to the needs of hundreds and even thousands of people. Cooking took place inside the massive kitchens, or sometimes outside during summer for other events. Here is chef Dominic "Mim" DeRenzo grilling filet mignon over an outdoor barbecue. For over 20 years, Mim served as the resident chef at Sunnybrook.

The Colonial Room was known regionally for serving up some of the best entrees. Freshness was always a high standard for the owners in the restaurant. For years, the Colonial Room had a lobster tank and even a second tank for fresh trout. Children would often gaze in wonder at the lobsters in one tank and the fish swimming about in the other.

With a fondness for antique items, the owners displayed many of their collectibles throughout the restaurant and ballroom. Over the years, Sunnybrook and the Colonial Room housed many interesting items. Besides dishes, paintings, household items, and even weapons, one might find an antique sleigh or an old carriage such as this particular one.

Exhibiting a vast collection of antiques and collectibles throughout the Colonial Room, it was often hard to display all the items at one time. Here an old small wagon is used as a dish cart. Of course, it blended in naturally with the other items throughout the restaurant. It was another ingenious use, giving new life to an old treasure.

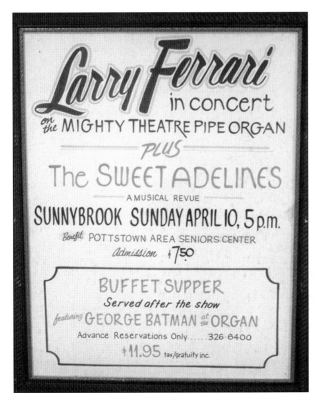

Larry Ferrari
in concert
on the MIGHTY THEATRE PIPE ORGAN

PLUS

The SWEET ADELINES
A MUSICAL REVUE

SUNNYBROOK SUNDAY APRIL 10, 5 p.m.

Benefit POTTSTOWN AREA SENIORS CENTER

Admission $7.50

BUFFET SUPPER
Served after the show
featuring GEORGE BATMAN at the ORGAN
Advance Reservations Only.....326-6400
$11.95 tax/gratuity inc.

On Sunday, April 10, Larry Ferrari, a famed organist from the Philadelphia area, was joined in the Sunnybrook Ballroom by the harmony of the Sweet Adelines. Providing a benefit concert for the Pottstown area seniors, Sunnybrook also hosted a buffet dinner for the fund-raising event. The gala evening was filled with music, entertainment, dancing, and food.

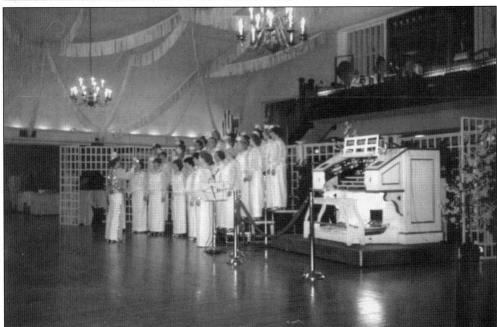

Entertaining the crowd in the splendid ballroom, the Sweet Adelines conduct a musical review for a seniors' benefit at Sunnybrook. Onstage with the mighty pipe organ, the Sweet Adelines accompanied local personality Ferrari that evening. Throughout the night, the sweet vocals filled the air and charmed the crowd.

In 1981, Sunnybrook celebrated its 50th anniversary commemorating the famed ballroom. Prior to the celebration, the owners purchased an antique theater pipe organ for the ballroom. Here Robert Hartenstine is seen with the organ, which was known as "Ursula." Overhead the open space above the stairwell is where the pipes would soon be installed along with the other accompanying instruments.

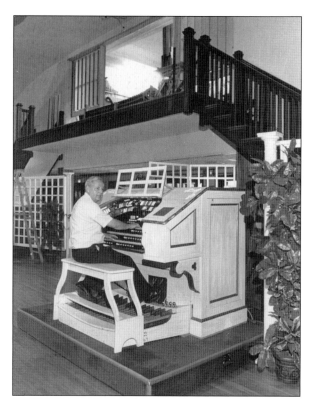

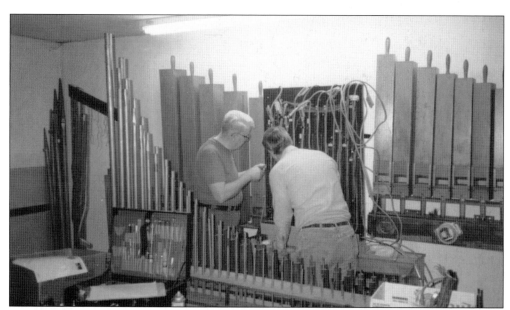

It was the 50th anniversary of Sunnybrook when the magical 1928 Opus pipe organ was bought and installed at the grand ballroom. High above the ballroom floor, just over the entrance, these men are working in what was a storage space that would be converted to house the magnificent pipes of the antique theater organ. Delicate care was taken with the musical device during the process.

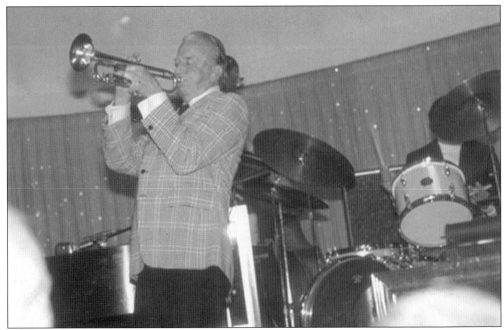

A trumpet virtuoso, Harry James was a prominent friend of the Sunnybrook owners. In 1939, James debuted his own big band in nearby Philadelphia and was the first bandleader to employee Frank Sinatra as a vocalist. James also married actress Betty Grable in 1943. Here James plays for a full house on the Sunnybrook stage in 1979.

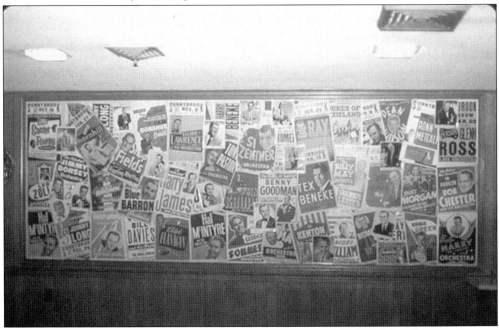

Just outside the Sunnybrook Ballroom, a wall of famous names is displayed for all guests to see as they arrive. Over the years, the concert posters and names have changed, but Sunnybrook's claim to fame was the multitude of big bands that had played on the stage. One tally of performances had totaled more than 300 bands at Sunnybrook before 1970.

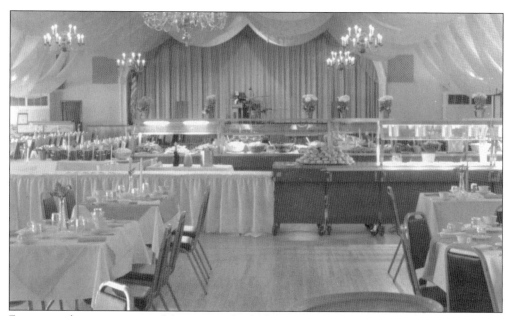

For major dining events and banquets, the ballroom was often converted and tables were arranged on the dance floor. Depending upon the type of event, one could have dinner and also dance the night away. For large buffets, such as this, the entire ballroom floor would become one large dining room. In lieu of big bands, solo performers would often entertain such crowds from the large stage.

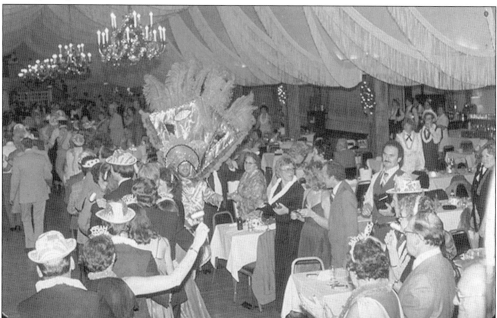

New Year's 1979 had the Philadelphia Mummers as guests in the Sunnybrook Ballroom. The popular organization mingles with the crowd of dancers as they shuffle through the hundreds of guests. With their wild and colorful costumes the Philadelphia Mummers were always a treat as they performed. Here one can see one of the extravagant outfits as it passes through the ballroom.

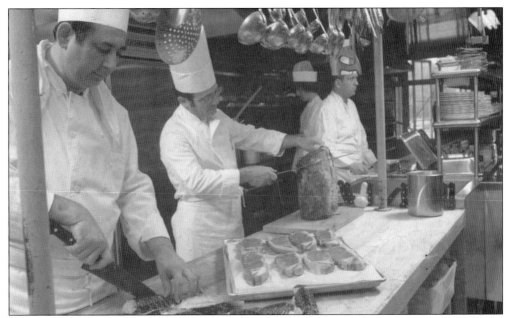

Preparing for a large dinner party, from left to right, chefs Dominic Viscardi, Dominic DeRenzo, Jack Ludwick, and John Hane are in the kitchen. For years, Raymond C. Hartenstine Sr. pursued Dominic DeRenzo to come and work for him. It was not until the foundation was laid that he knew the owners were serious about building a restaurant. Giving up his own business, DeRenzo began his long-term career at Sunnybrook.

Here is another view of the service line in the Sunnybrook kitchen. Here is chef DeRenzo coordinating desserts for the guests. One minute DeRenzo and his staff would be operating the restaurant and serving dinner in the Colonial Room, the next day they might be catering to several thousand people in the ballroom.

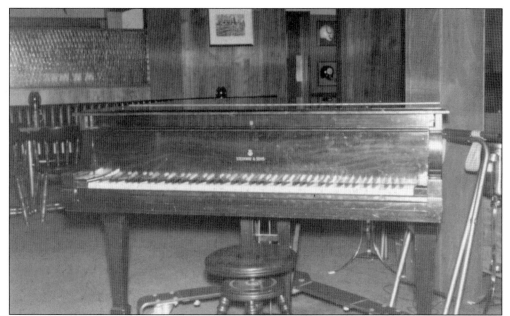

Inside the Colonial Room people could often listen to a variety of musical numbers while they dined. On Saturday nights, they could hear modern music in the tavern and big band sounds coming from the adjacent ballroom. Before the ballroom had its famous organ, the Colonial Room had its very own piano for the entertainment. The piano was used in both the ballroom and restaurant.

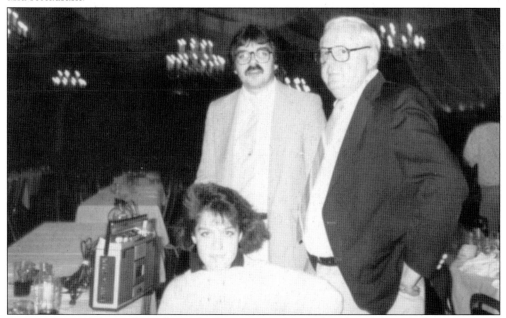

As a recognized figure throughout the later years of Sunnybrook, celebrated organist George Batman, seen in the center, provided many hours of entertainment at the ballroom. His melodious fingers danced across the antique organ, filling the days with wonderful music. Here Batman is accompanied by his daughter Kimberly, and, at left, a very familiar face at Sunnybrook, one of the owners, Robert Hartenstine.

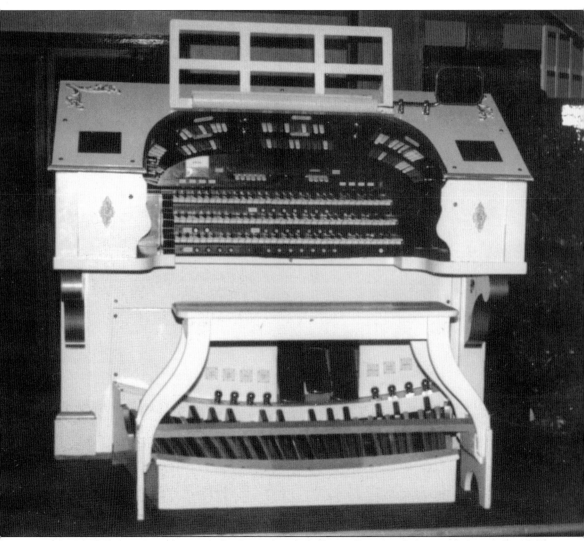

The U.S. Theatre Pipe Organ in the Sunnybrook Ballroom boasts a three-manual console, a full pedal, and 11 ranks of pipes. The organ is played for special events, during dinners, and for the Sunday brunches. Amazingly the organ also has a marimba, a xylophone, castanets, cymbals, gongs, a drum, a car horn, sleigh bells, a siren, and police whistles as part of its ensemble. The organ was originally built for the Lansdale Theatre to accompany silent films of the era. Nicknamed "Ursula," the pipe organ was eventually removed from the theater and set up again in a church. The organ was installed at Sunnybrook in 1981 for the 50th anniversary of the ballroom. The organ itself was built in 1928 and is a certified antique of great value. For years, the beloved sounds of the pipe music filled the ballroom.

In 1988, *Annie* actress Aileen Quinn graced the stage at Sunnybrook with her charm, talent, and beauty. Singing several selections from the musical hit, the teenage star had become all grown up since her days of movie fame. Her arrival at Sunnybrook was as a guest vocalist for the Pottstown Symphony Orchestra during their "Pops" concert.

Even that famous fellow in the red suit, Santa Claus, made several appearances at Sunnybrook. Here Santa sits in the Colonial Room waiting for a line of children to pay him a visit. Throughout the years, Kris Kringle would appear at the Christmas brunches with a bag full of toys for all the children. Many children had such fond memories of those times at Sunnybrook.

Across the creek from Sunnybrook, the family farm was still in use. Throughout the years, family members could be seen in one of their sleighs or even carriages as they traveled about the property. Here coming from the stables is Ray Hartenstine Jr. and one of his daughters, Amy. Many times, the owners would also display their sleighs and carriages in the ballroom to help decorate for the holiday seasons.

Outside the main entrance to the grand Sunnybrook Ballroom, the facility staff poses for a picture on Mother's Day 1975. Many of the larger buffet dinner occasions were served in the grand ballroom due to the sheer size of the crowds. A record attendance for Mother's Day was set a few years later when more than 1,400 people attended the lunch and dinner date.

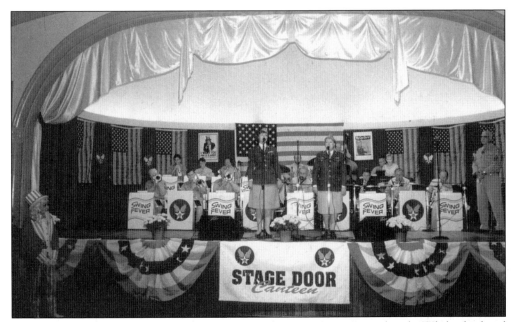

Each year, local groups sponsor a World War II dance event at Sunnybrook. While the band Swing Fever provides the entertainment for the dance, veterans share a memorable evening. Dressed in full military attire, the band, as well as its guests, relive a special time and place in history. Defending the world from tyranny, these veterans are a truly special generation that can never be thanked enough for the sacrifices they endured.

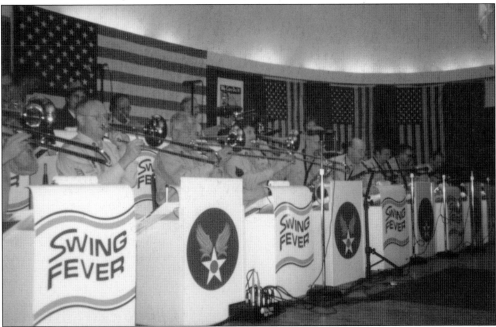

The sounds of Glenn Miller, Tommy Dorsey, Sammy Kaye, and dozens of other groups are re-created by the Swing Fever band. Many of the veterans celebrating the night's events had come to Sunnybrook as teenagers years ago. Many of them had met their spouses here, and many of them said good-bye to their best friends as they set off to war.

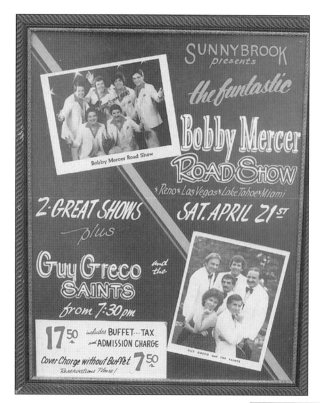

Between the returning big bands, many of them with new bandleaders at the helm, Sunnybrook also booked exciting new acts and local bands. Here a poster shows headliner the Bobby Mercer Road Show. However, over the years, it was the local act Guy Greco and the Saints who packed Sunnybrook. Eventually it was Guy Greco who became a popular, top attraction at the ballroom.

Posing for a picture at the World War II dance, Bill Krause and his wife, Sue, pause for a moment. As co-organizers of the annual event, Bill and Sue dedicate many of their hours to their friends and veterans alike. Helping to support the endeavors of the organization that puts on the dance, a great group of friends makes it a celebrated success each and every year.

George Batman is seated here at the antique pipe organ. After the anniversary celebration, Batman would perform on a weekly basis for the crowds at Sunnybrook. A local native of the area, Batman was well known, entertaining brunch crowds and thrilling listeners with musical numbers during intermissions for other bands. Often Batman became the opening act in the ballroom and later played piano and keyboard in the adjacent Colonial Room.

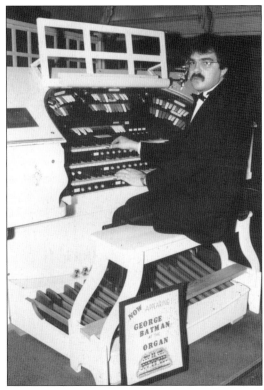

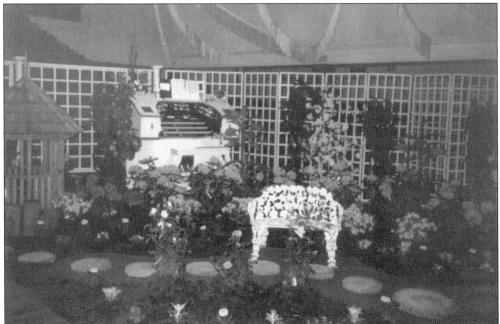

In the mid-1980s, the ballroom is vividly decorated for a home show or, perhaps, one of the garden shows at the ballroom. Set among the lush garden, the historic organ is ready to be played for a night of entertainment. Once again, Sunnybrook welcomed local organizations, weddings, and various other groups that used the ballroom to host their massive events.

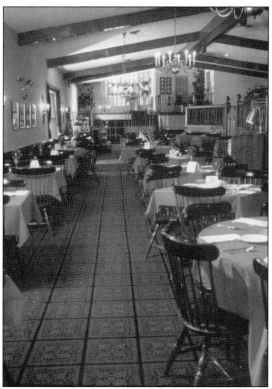

Looking toward the entrance of the Colonial Room, this is a panoramic view of the facility showing its true size. The restaurant and tavern accommodated nearly 200 patrons. Voted one of the area's most elegant restaurants at the time, because of the fine food and wonderful decor, the Colonial Room was very prominent throughout the region.

This is a behind-the-scenes look into the massive kitchen at Sunnybrook. Here a small portion of the workstations and the prep line can be seen. Not only was this kitchen used daily for the Colonial Room, but it also provided service for large banquet events that were booked in the ballroom. At the time, the kitchen was ultramodern and built to handle hundreds, even thousands, of guests at a time.

Taken in the mid-1970s, this rare photograph of Woody Herman is from the Sunnybrook Ballroom. Over the decades, Herman and his orchestras often made stops at Sunnybrook. During this particular event, the equally famous drummer Buddy Rich played in the band and later appeared again with different acts. Even today, Herman's autograph remains backstage on the "wall of fame" behind the ballroom.

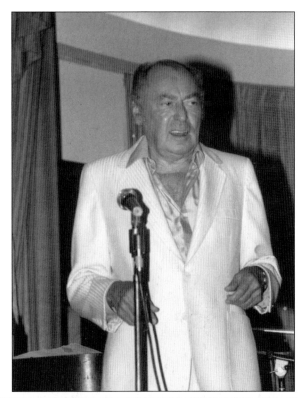

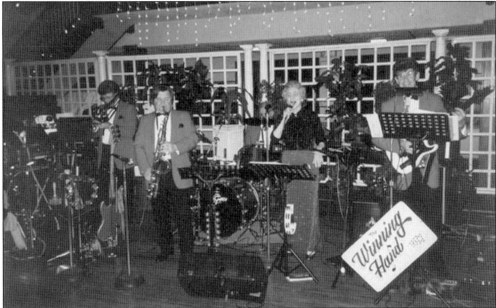

Taken at the Christmas dance on December 16, 2001, this photograph of the Winning Hand marks the end of an exciting era. Unknown by those who attended that night, this was the last formal dance held at Sunnybrook and the Winning Hand was the last band to play the marvelous ballroom. From left to right, the band members are Gerry Green, Gary Shupp, Jon Maury, Gloria Hipple, and Norman Faut.

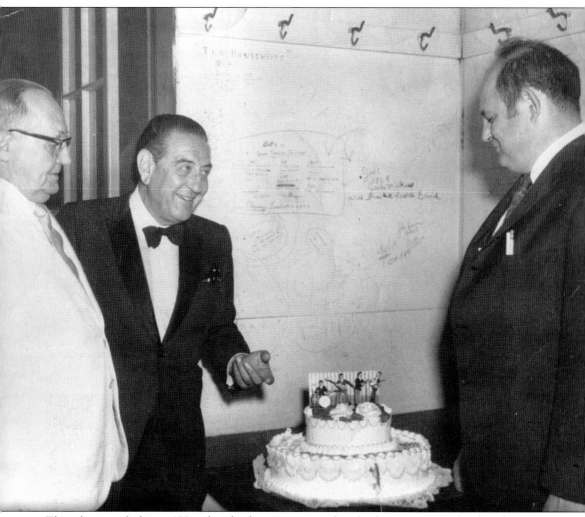

This photograph from 1972, taken backstage at Sunnybrook, shows Guy Lombardo, who was celebrating his 70th birthday. With him on the left is Raymond C. Hartenstine Sr., and on his right is Ray Hartenstine Jr. This is one of the last photographs of Raymond C. Hartenstine Sr., who passed away the very next month. Over the years, Lombardo had become a good personal friend to the owner's family and had performed at Sunnybrook many times. All smiles, Lombardo gazes down on his cake with, of all things, a Beatles topper. He is standing before the famous wall of autographs, which at one time had more than 300 autographs etched upon it. Lombardo was a violinist and popular Canadian bandleader who had a huge following in the United States. Eventually he became a U.S. citizen and lived the rest of his life in the states until his passing in 1977. An interesting fact, it is Lombardo's rendition of "Auld Lang Syne" that is still the first song played each New Year's in Times Square.

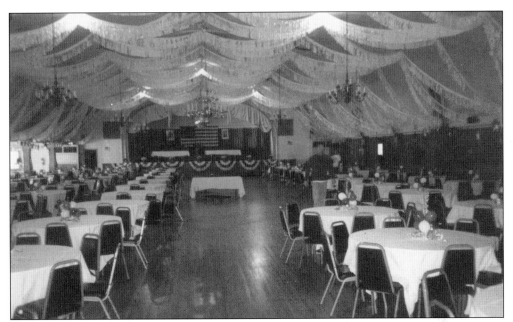

This picture shows the ballroom staff finishing the setup for a World War II dance program. Preparations in the kitchen are already in full swing, while more than a dozen members of the workforce get the ballroom in order for the night's main event. Within a few hours, more than 1,000 veterans and their families will be entertained at Sunnybrook for their annual reunion and swing dance.

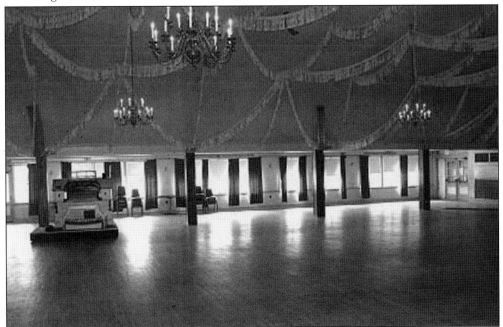

Taken after a major event, this image shows the south side of the ballroom and a wall of windows. Looking in this direction, through the windows, one would be gazing out at the massive swimming pool. As the staff finishes the cleanup after an event, the massive ballroom looks very empty as only some decorations remain.

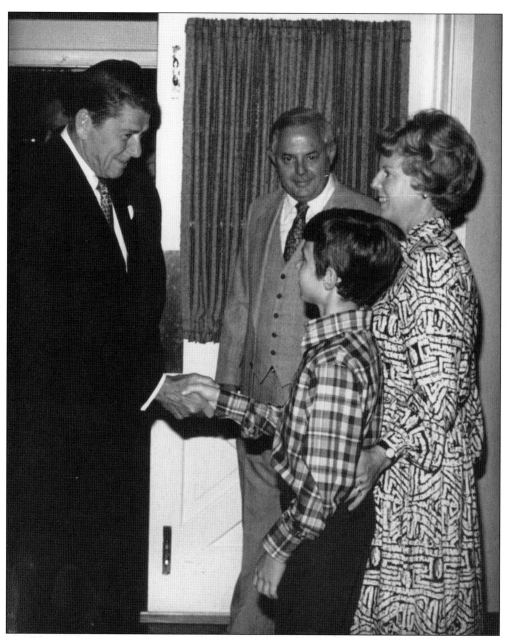

Over the years, several presidents and various presidential candidates, including Richard Nixon and George H. W. Bush, visited Sunnybrook for their regional conventions. Here Ronald Reagan is on the campaign trail just before his election. During such rallies and events, thousands of people would attend, and different place settings would be used throughout the ballroom and restaurant. A former actor and the previous governor of California, Reagan was a popular candidate for the coming election and, of course, won the presidency. For this event, there was a dinner and rally inside the ballroom while other programs were held outside. One estimate for the event put the number of the crowd at nearly 7,000 people. Pictured in the photograph with Reagan is Robert Hartenstine; his wife, Nancy; and their eldest son, who is shaking hands with the soon-to-be president of the United States.

Five

SUNNYBROOK TODAY

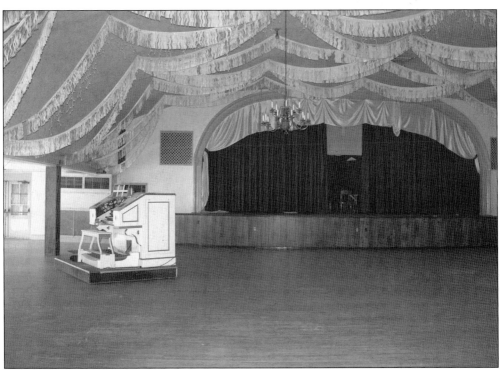

A picture of the Sunnybrook Ballroom taken in 2002 shows the grand stage and decorative setting that still adorns the ballroom. The antique pipe organ sits atop its movable platform at the front of the ballroom. Whenever it was played, the organ was moved to the back of the ballroom, near the entrance. Like a picture from the big band era, the stage still looms large before an invisible crowd.

Beneath the overhang, the original entrance to the grand ballroom is locked and shuttered. Over the years, Sunnybrook was enlarged in 1938 and then in 1963 with the addition of the restaurant. Renovations occurred in 1968 and again in 1995, when the restaurant was converted to a brewpub. Although the ballroom remained in operation for years afterward, it eventually closed in 2004 for the last time.

Over the years, many notable personalities and guest performers had walked through those doors on the left and into the ballroom. The backstage doors of the Sunnybrook ballroom have since been covered with wood and sealed shut to keep looters from entering the building. For more than 70 years, distinguished big bands and other groups carried their equipment through these very doors to set up for their nightly performances.

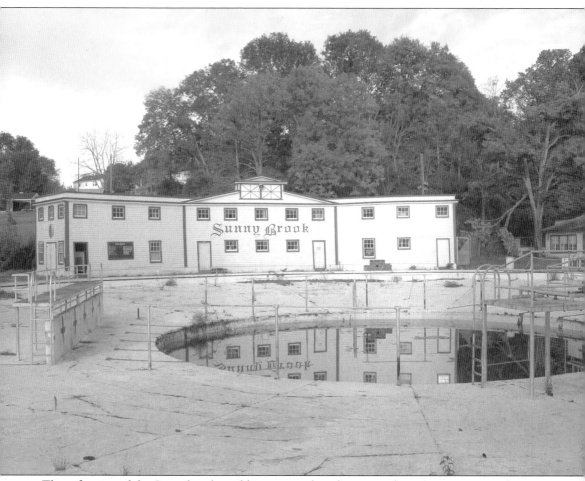

The reflection of the Sunnybrook pool house provides a haunting glimpse into a mirrored past. To the right, two of the original low-dive platforms still remain near the center. The original high dive is long gone and was eventually replaced by two catwalks, one of which is visible on the left side of the photograph. Visitors to the pool today can see how it sloped into the center diving area. The pool depth ranged from three feet at the sides and dropped to approximately 15 feet in the center area. The pool was said to accommodate a capacity crowd of 800 people. The pool itself was utilized as a swim club, then a public pool, and even had several swim teams over the years. From 1926 until 1999, the pool was in continuous operation and had gone through very few modifications from when it first opened.

Gazing out from the ballroom entrance to the wintry grounds, this image looks east toward the pavilion. Even in winter, the old ballroom, situated between modern homes and townhouses, stands as a reminder of a bygone era. Over the years, thousands of people were dropped off at this entrance, bought a ticket at the box office, and attended a concert or other function just inside the grand ballroom.

Where the old picnic pavilion once stood until the 1960s, a new and modern pavilion building has been erected. Similar to the original in wood construction with moveable sides, this pavilion provided a comfortable space for outdoor events, including polka concerts and even country line dancing. Today a gazebo sits directly between the ballroom and pavilion and provides photograph opportunities for many patrons.

Over the years, Sunnybrook has gone through several remodelings and a few renovations. At the front of what was once the Colonial Room, a patio has been built for diners to enjoy the outdoors. To the far right of the picture, the brew tower looms large over the current entryway to the restaurant.

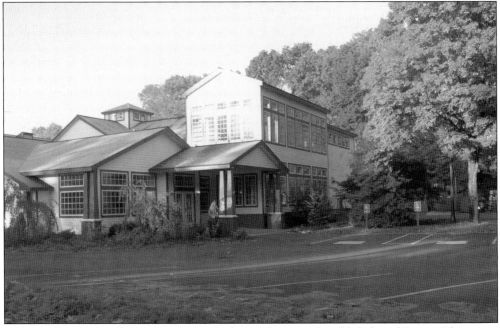

Today a glass-enclosed brew tower stands above what was the old Colonial Room. This tower houses brewery equipment, a small bar, and several additional dining tables for patrons. Built in 2000, the brewery was attached to what was the side of the Colonial Room, thus changing the entrance to where it stands today.

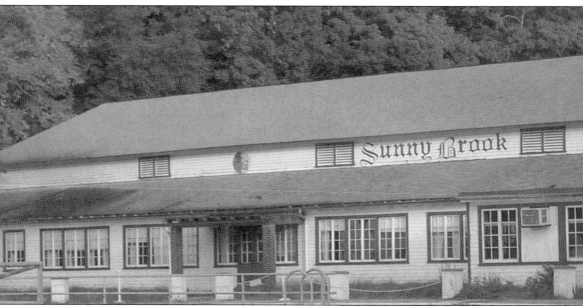

This is an image of the famed Sunnybrook Ballroom as it stands today. More than 70 years later, the wood frame building still holds the memories of the hundreds of orchestras, bands, and groups that played here over the many eras. Sunnybrook saw the rise of the big bands as well as rock and roll. Its massive ballroom catered to the eclectic sounds of various types of music for decades. Today the ballroom has been shuttered after several failed attempts by new owners to

operate the famed venue. Even now, a nonprofit foundation is working to save the facility and renovate the grand ballroom for new generations to enjoy. In 2005, the Sunnybrook Ballroom and the accompanying swimming pool and restaurant were listed on the National Register of Historic Places. It is the hope of the foundation to save Sunnybrook from development and possibly destruction.

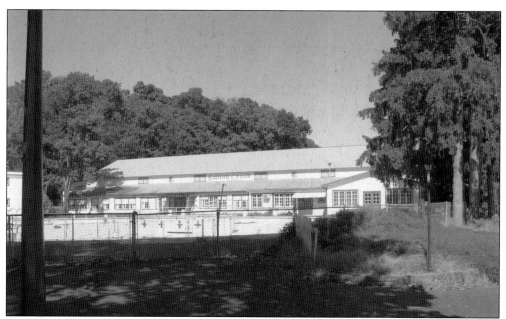

Closed in 2000, the swimming pool was drained and a few years later condemned by local authorities. It was the hope of many locals that their favorite swim club would someday be reopened for new generations to enjoy. However, the Sunnybrook pool has now outlived its founding family and remains as a memory of a past that was filled with wonderful summers spent at Sunnybrook.

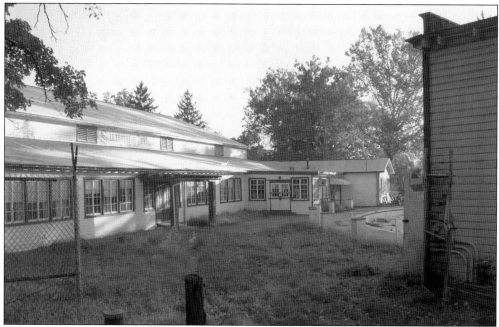

The trellises have long been gone and the trees and grass have grown over the grounds, but the side entrance to the ballroom still remains. Part of the original addition to the ballroom was a new concession stand and storage space for the ballroom. Looking between the ballroom and the pool house on the right, one gets a glimpse of the side entry as it is today.

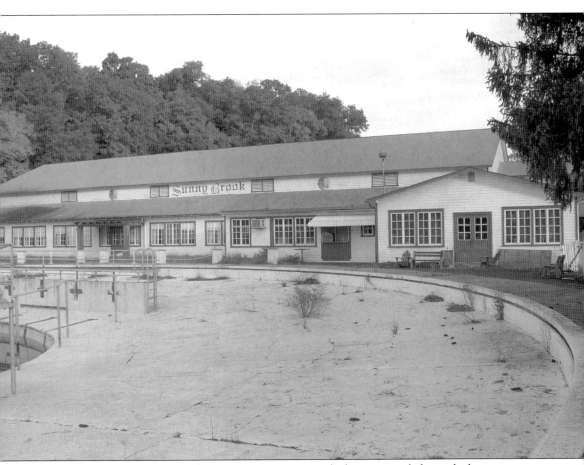

As weeds and grass start to overtake the swimming pool, the concrete behemoth that was once Sunnybrook pool gives in to nature. Today the pool itself stands as being condemned by local authorities. Facing north, the massive ballroom stands watch over the premises. The awning toward the middle once covered the concession stand windows as people waited in line for refreshments that included soda, snacks, and ice cream. To the right, the twin doors of the storage room are bolted shut. From the swimming area, there were three entrances into the ballroom. Where the original pool pavilion once stood, a small grove of pine trees now occupies the spot. At the right of the photograph is the storage room of the ballroom, which was added during one of the three remodels of the facility years ago. Surrounding the pool itself are several of the small brick pillars that once held the trellises that shaded the pool area.

Where there were once large windows in the Colonial Room, there is now a high-story tower that houses the brewery equipment. Constructed and renovated as a brewpub by its first owner since the Hartenstine family, Sunnybrook was reborn, to the dismay of many, as a brew tavern. People who had once dined among antiques from Colonial days now sat beneath tanks of steel and copper.

What was once the Colonial Room was renovated and reconstructed as a brewpub in 2000. From between the pillars of the newly erected brewery tower, the image shows chairs atop tables in what was once the well-decorated restaurant. After selling Sunnybrook to a new investor, the family of the original owners and the general public watched as the business was turned into an upscale bar and restaurant.

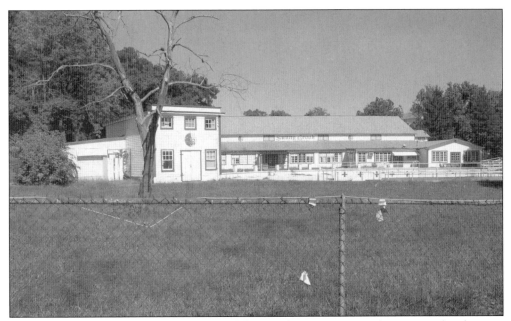

Behind the chain-link fence near the pool house, the commotion of yesteryear has become silence. Looking north toward the pool house and ballroom, the empty swimming pool sits idle as nature reclaims the land around it. On the rolling farmland, hundreds of townhomes and modern houses now surround the 17-acre parcel where Sunnybrook sits today, as urban sprawl has claimed the original family farmlands.

Once illuminated throughout the nights and advertising hundreds of big-name performers, the Sunnybrook sign stands alone at the edge of the historic property. This sign once promoted some of the most famous names of the big band era. Today the sign stands in disrepair and has been marked by graffiti. With hopes for a bright future, many people look to see that same sign illuminated again.

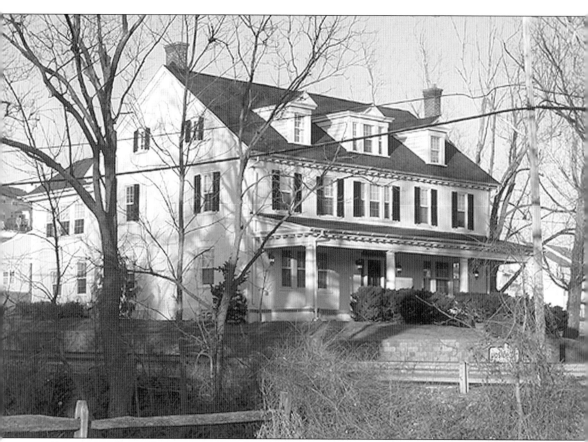

Just across the road near Sunnybrook, over a small wooden bridge, the old family farmhouse still remains. Although the barn and other buildings of the homestead have long since been demolished, the Colonial-era house still stands. The massive home once saw the likes of the Kepler-Bickel and Buchert and Hartenstine families raised within its walls. Although the property itself was granted to the families in 1732, the farmhouse is said to date from the 1750s. Over the years, the house has been remodeled several times. A large addition of more rooms was added to the back of the old house, while two new dormers were placed on the rooftop at either side of the original single dormer. In time, the front porch was also renovated and now has four pillars along its edge. Today the old farmhouse has been remodeled inside as well and has been whitewashed on the exterior. It is now used as office space for local companies.